Watercolour Flower Painting
Step-by-Step

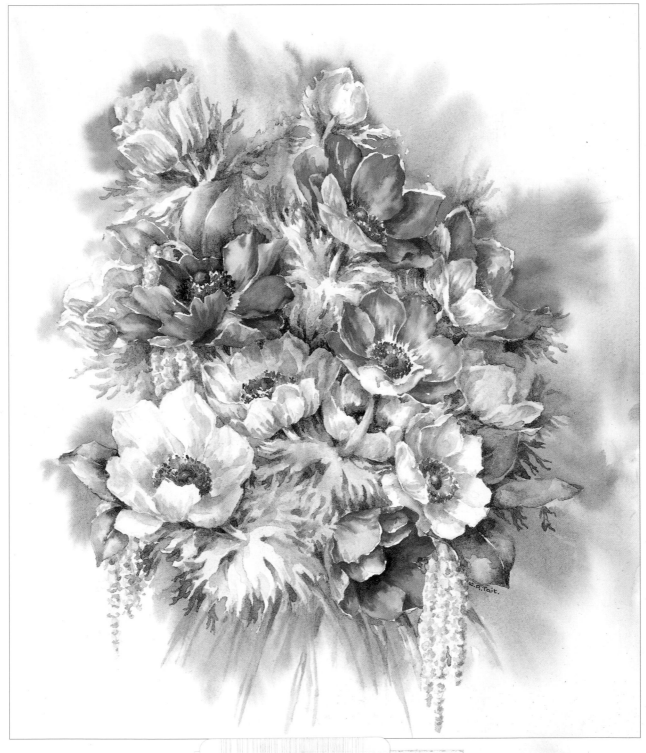

First published in Great Britain 2012

Search Press Limited
Wellwood, North Farm Road,
Tunbridge Wells, Kent TN2 3DR

Based on the following books published by Search Press:

Step-by-Step Leisure Arts series:
Wild Flowers in Watercolour by Wendy Tait, 2003
Flowers in Watercolour by Wendy Tait, 1999
Light in Watercolour by Jackie Barrass, 2000
Creative Watercolour Techniques by Richard Bolton, 2000

Watercolour Tips and Techniques series:
Flowers in the Landscape by Ann Mortimer, 2009

Text copyright © Wendy Tait, Jackie Barrass, Richard Bolton and
Ann Mortimer, 2012

Photographs by Charlotte de la Bédoyère and Debbie Patterson,
Search Press Studios.

Photographs and design copyright © Search Press Ltd. 2012

ISBN: 978-1-84448-736-3

The Publishers and author can accept no responsibility for any
consequences arising from the information, advice or instructions given
in this publication.

Suppliers
If you have any difficulty obtaining any of the materials
and equipment mentioned in this book, please visit the
Search Press website: www.searchpress.com

Publisher's note
All the step-by-step photographs in this book feature the
authors, Wendy Tait, Jackie Barrass, Richard Bolton and
Ann Mortimer, demonstrating watercolour painting techniques.
No models have been used.

Printed in Malaysia

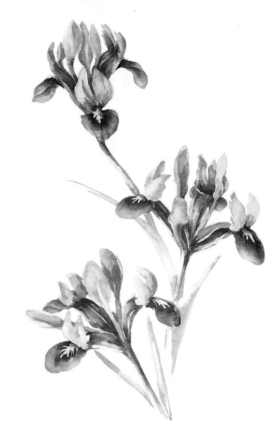

Cover
Summer Days by Wendy Tait

Page 1
Anemones by Wendy Tait
*These wonderful anemones were bought off a market stall. They
lasted all week in a cool place, obediently closing at night and
opening the next day. They were painted using cobalt blue deep,
Winsor violet, quinacridone magenta, Winsor orange, Winsor
lemon, Payne's gray and my green mix of Winsor yellow and
Payne's grey mixed with a little indigo.*

Page 3
Chrysanthemums and Honesty by Jackie Barrass
235 x 330mm (9¼ x 13in)

*These big shaggy flower heads contrast sharply with the paper-thin
seed pod linings of the Honesty to create an almost abstract design.
No masking fluid was used, but some highlights were lifted out by
using the softening technique.*

Pages 4–5
Poppies and Corn by Wendy Tait
*I really enjoyed the feeling of painting these poppies very loosely,
letting the colours run together without worrying too much about
detail or accuracy. I used Winsor lemon, gold, Winsor orange and
quinacridone magenta for the petals, dropping in ultramarine with
a touch of Payne's gray and my green mix of Winsor yellow, Payne's
grey and a touch of indigo for the centres. The colours, tones and
softened edges convey a feeling of relaxation and contemplation at
the end of the day.*

Watercolour Flower Painting Step-by-Step

WENDY TAIT, JACKIE BARRASS, RICHARD BOLTON AND ANN MORTIMER

SEARCH PRESS

Contents

Materials

You do not need many materials for watercolour painting – in fact you can get by with just a palette and a small selection of paints, brushes and papers. Once you have found materials that you are happy with, it may feel safe and reassuring to continue using them. However, do explore other alternatives, as occasionally they can be most stimulating.

Paints

Watercolour paint is available in either pans or tubes and in two grades – students' or artists' quality. The artists featured in this book recommend starting with a limited palette of colours and learning how to mix further colours from these. This simplifies the colour mixing process and helps to keep individual paintings harmonious.
Their own personal choice is included in each chapter, so you can try out different approaches and find the combination that best suits your style. The artists agree that while artists' quality paint is more expensive, it produces stronger, more intense results and goes further in the long run.

If you are just starting out, buy four tubes: a yellow, a blue and a red, and an earth colour (such as burnt sienna). As you mix your colours and experiment, you will see how many different shades you can produce with these basic colours. You will also soon see which extra colours you might need, such as a pink or a violet, depending on the flowers you choose to paint.

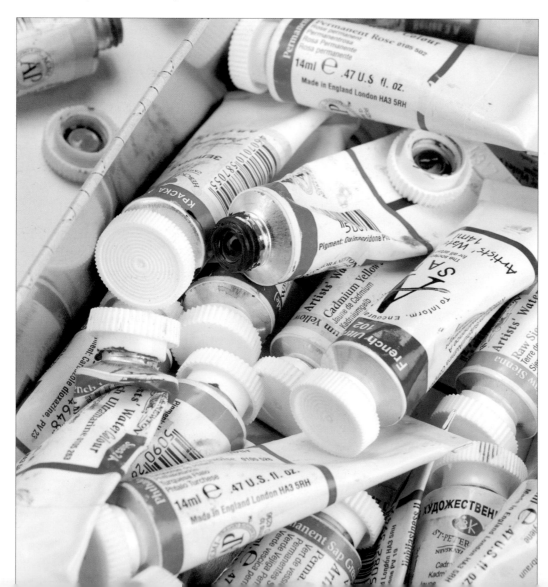

Tubes of watercolour paint.

Palettes

There are lots of different palettes on the market from which to choose, including round radial palettes, square porcelain palettes and palettes built into paint tins. It is important to keep your colours clean, and to have plenty of space for mixing colours. For these reasons, look for a palette that contains a number of separate wells large enough to prepare sufficient amounts of any particular mix.

Like the paints, you should experiment with different types of palette until you find one that works well for you.

Tip

If you always keep your colours in the same position in your palette, you will gradually get to know their names and be able to distinguish each colour from the others.

This palette contains space for pans of watercolour paint in addition to large mixing wells.

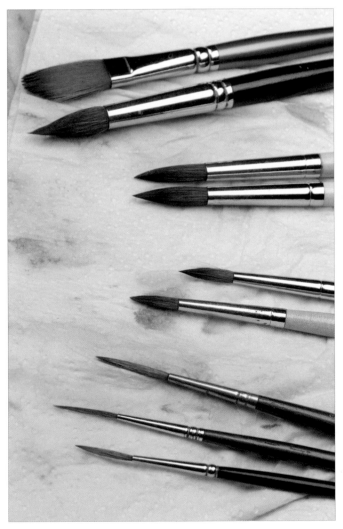

Brushes

There are a variety of brushes available. Sable are the best quality as they hold the colour pigment well, but you can also use sable and ox-hair blends or synthetic brushes.

It is a good idea to start painting with large brushes – this will prevent your paintings from becoming fussy and overworked. Your brushes should hold a good amount of pigment and water to allow you both to lay washes generously and manipulate the paint sensitively.

- The most versatile brushes are **rounds**. Providing it has a good point, a large round brush can be used for quite detailed work as well as large washes.

- **Large flat** brushes are useful for laying down broad strokes of paint and can also be used side-on for straight lines.

- Fine **riggers** enable you to complete fine linear detail such as the delicate tracery of stems and veins.

- A **mop** or **hake** brush is useful for softening, lifting out highlights, removing salt from a painting and large washes.

Ensure that your brushes are carefully cleaned after each painting session. You should also rinse brushes thoroughly when changing colours to keep your washes clean and vibrant. You may decide to have several brushes on the go during one painting – one for each individual colour; and you may find it helpful to have two brushes on the go at the same time: one to lay the wash and another 'back-up' brush – clean and dipped in water – to spread and blend the wash.

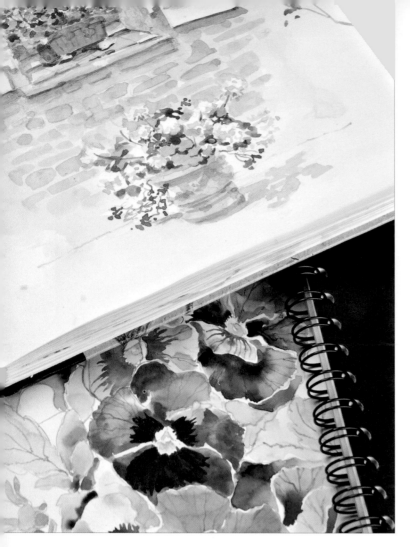

Sketchbooks

Small sketchbooks can be used to record any interesting scenes, subjects or colours that you come across. The reward of looking through old sketchbooks and seeing the fresh, spontaneous work is always an inspiration. A4-size hardback sketchbooks with cartridge paper inside are convenient and very sturdy: an important quality when filled with pencil, pen and watercolour sketches.

In addition to allowing you to practise your drawing skills, the other main reason to use a sketchbook is to prepare tonal sketches and to try out different compositions before starting to paint. These are worth keeping for future reference.

There is no pressure to produce a great masterpiece in a sketchbook, and as a result artists can often produce their most spontaneous and relaxed work there. More information on sketching can be found on pages 26–29.

Paper

Using good-quality paper makes all the difference to your work and helps you to enjoy the painting process, so producing a better result. It is important to have a sturdy, well-made textured surface upon which to lay washes, so use good-quality watercolour paper. Think of it as an investment towards your future skills.

Watercolour paper is available in sheets, pads or blocks. Blocks are gummed all round the edges and the sheets do not need stretching. There is a choice of surfaces: Hot Pressed (H.P.) has a smooth surface; Not, or Cold Pressed, has a slight texture; Rough has a heavier texture. Each type is useful for different effects, so experiment with different papers.

Light-weight papers – anything under 300gsm (140lb) – require stretching to prevent sheets from curling when washes are applied. Medium-weight papers, such as 300gsm (140lb), may still need to be stretched, depending on how wet you like to work. Heavier papers, such as 425–600gsm (200–300lb), do not need stretching and will stand any amount of rough treatment. Instructions on how to stretch your paper are provided on page 14.

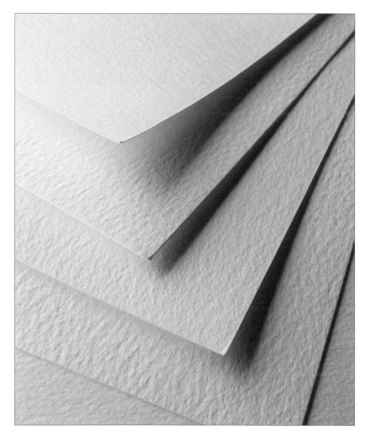

Other materials

- A **board** is essential to keep your paper flat and to make the painting portable. It is easily picked up and moved about to allow washes to spread and merge. It needs to be 5cm (2in) bigger all round than the paper you are using.

- **Masking tape** is useful for attaching paper to the board along all four sides.

- **Masking fluid** is used to protect areas of the painting surface that you wish to keep clean.

- **Colour shapers** are good for using with masking fluid for fine lines such as stamens.

- Keep several sheets of **kitchen paper** under your brushes so you can control the amount of water on the brush by dabbing it on the paper.

- Use a **2B pencil** to draw the composition and a soft pencil such as a **4B** or **6B** for sketching and shading.

- Fine-tipped nonpermanent black **pens** are useful for initial sketches.

- **Salt** and a **sponge** create terrific textures, and **candles** can be used for wax resist effects.

- **Tissues** should always be close at hand for soaking up drips and to create texture in a wash.

- A **toothbrush** and **palette knife** are useful for spattering.

- Keep a **putty eraser** nearby to remove pencil marks.

- A **spray bottle** is used to re-wet paper when laying in an initial wash.

- A **craft knife** can be used for scratching out highlights and sparkles on water surfaces.

- A **water pot** or **cup** is essential to wash brushes and provide clean water for painting.

- A **hairdryer** is used to encourage washes to dry.

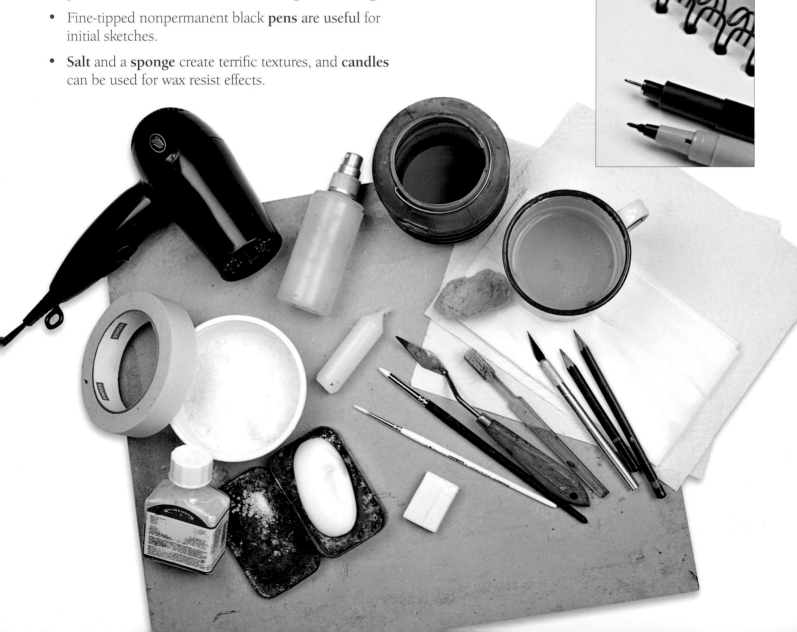

Basic techniques

The following pages look at basic techniques and terms used when painting flowers in watercolour. Concentrate on the basics until you have gained confidence. It is important that techniques are used only as aids to help you express your own ideas – do not let them take over your paintings. Suggest and simplify and let the viewer's eye complete the image. Remember that just a few brushstrokes can indicate quite detailed forms.

Washes

Washes can be flat, with one colour and tone all over, or they can be graded from dark to light by the gradual addition of water to the paint mixture. If you use two colours or more for a graded wash, it is called a variegated wash.

In each case, plenty of fluid paint must be mixed before you start as the colour needs to be applied quickly over the entire surface. Reload your brush after each stroke.

You can work on to dry paper or dampen the whole surface with water first so that the paint spreads more readily.

Your board should be tilted slightly to allow excess paint to flow down the paper or, if you are working dry, to collect at the bottom of each horizontal brushstroke and be picked up on the return journey.

Puddles collecting at the bottom of the paper should be removed with a damp brush or absorbent paper. This will prevent them from running back into the drying paint or soaking into the gummed tape and loosening your paper.

One-colour flat wash

One-colour graded wash

Wet-into-wet

Paint can be applied to a wet surface to produce a soft, diffused, ghostly effect. The wetter the paper, the less control you have. Interesting effects can be obtained working into a surface that is only slightly damp. It is a good idea to spend time testing the results that can be obtained using varying degrees of wetness.

It is probably best not to complete an entire painting with this technique, but it can be used in the initial stages and on selected areas. When combined with crisper hard-edged washes to define form, it helps to create atmosphere and unity. With practice, you can learn to judge how wet your paper is by the amount of shine on its surface.

Wet-onto-dry

Paint can be applied on to dry paper and then left to dry completely before overlaying with another colour. This gives you complete control but as a technique it is, perhaps, less exciting than wet-into-wet. I prefer to combine both methods – however, there may be times when a certain type of light, such as bright sunlight, requires just wet-onto-dry to give a crisp sparkling finish. Always think about the technique best suited to convey the mood of your subject.

Dry brushwork

This technique is perfect for creating texture and broken colour. A minimum of paint is applied to the brush and this is then dragged across the paper. The technique works best on Rough paper.

A variety of subjects from grass and foliage to rust and rock formations can be depicted by simply varying your brushstroke and brush size.

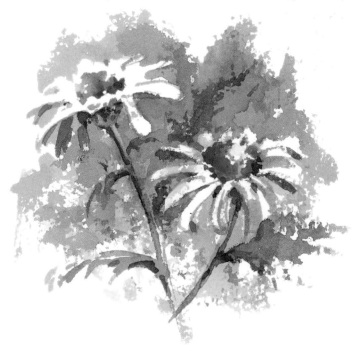

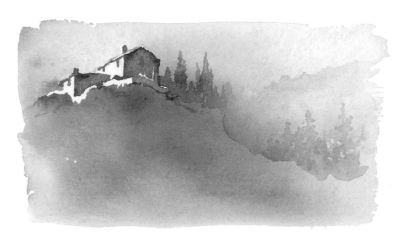

Positive and negative

This technique is also known as 'push and pull'. When painting a well-lit object you should lay down the initial wash, let it dry and then simply paint the darker area around your lit subject matter to bring it into focus. Work in reverse for dark objects seen against a well-lit background. This sounds like an obvious technique but it is often overlooked.

Softening

After carefully wetting a selected area you can use a cotton bud or soft brush to blend or merge unwanted hard-edges. Small, soft highlights can also be lifted out in this way. Be aware that certain pigments stain the paper, making it impossible to get back to a really white surface. In addition, some papers hold on to pigment more than others.

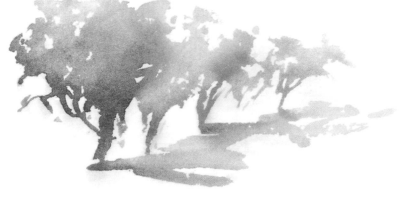

Masking fluid

Masking fluid is often frowned upon by purists but it can be very useful for protecting small details and highlights that would otherwise be impossible to retain using conventional methods. It should be used with discretion as it has a tendency to look artificial and it can stifle spontaneity. Masking fluid can be tough on your brushes, so either use an old brush or rinse your brush very carefully immediately afterwards. Do not remove masking fluid until the paint is completely dry. Once removed, the white areas that are exposed may need to be washed with colour to suggest form and make them 'sit' correctly in the painting. Masking tape can be used in much the same way as masking fluid – for example on the straight edge of a stem.

Backruns

Backruns look like accidents but they are used purposefully by many artists to great effect. Unplanned backruns can be a nuisance to a beginner and are only resolved by lifting out. They occur when fresh colour is applied to a wash before the previous layer is dry – the result is that the new paint creeps into the old. The unusual textures and edge qualities can, however, be incorporated into your painting.

Granulation

When pigment settles out of a wash into the grain of the paper it can produce lovely atmospheric speckles. This effect is known as granulation. It can add subtle interest to otherwise flat areas of paint. Certain pigments are prone to this effect (French ultramarine, for example) and some papers react better than others. Rough paper is particularly good to work on as it has an uneven surface.

Salt

Crystals of sea salt can be scattered into wet paint then left to dry to produce lovely snowflake-like shapes. This effect is caused by the salt absorbing the surrounding pigment.

Stretching paper

Lighter-weight papers (see page 8) will need to be stretched before you can apply washes to them. This will prevent the paper from cockling and will give you more control when applying paint. Use gummed paper tape or masking tape at least 40mm (1½in) wide and a rigid wooden board (not hardboard). The stretched paper should be left to dry flat for at least five hours or preferably overnight. Do not try to speed up the drying process by using a hairdryer as this may tear the paper or make it dry unevenly and pull away from the board.

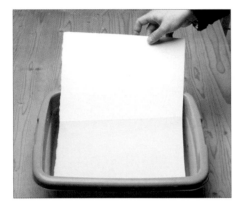

1. Soak the paper in water for a few minutes until it expands and relaxes. Shake off excess water.

2. Lay the paper on a wooden board. Dab the edges of the paper with absorbent paper.

3. Dampen strips of gummed paper tape using a large paintbrush. If you are using masking tape, you can skip this stage.

4. Use the dampened tape to attach the paper to the board. Leave it to dry flat for at least five hours.

5. The paper is now ready to paint on. Do not worry if any 'cockling' occurs when you are working, as the paper will tighten up again as it dries.

6. When you have finished your painting, cut it from the board using a craft knife.

Daisies

17.5 x 24.5cm (7 x 9½in)

Jackie Barrass worked with a limited palette of only three colours to give a quick, spontaneous response to the crisp freshness of these flowers.

Using masking fluid

Masking fluid helps to create contrast by preserving areas of bright white paper and is an important part of the way I paint. Over the years, I have developed a trouble-free way of making sure it works – masking fluid without tears, if you like.

It is important to bear in mind that the fluid is a latex-based substance that can be difficult to remove from fabrics, so it does need to be used with care.

Useful tips for using masking fluid

In my experience, if you follow these guidelines, you can leave masking fluid on for days with no ill effects.

- Use a good brand of masking fluid. It needs to be liquid and easily spreadable, so do not use fluid that has been lurking in the back of a drawer for years.

- The shape that you create with the masking fluid is the shape you will be left with when you rub it off: a carefully painted leaf will look like a carefully painted leaf in the final picture. Equally, a misshapen splodge made with a stubby old brush clogged up with old masking fluid will look like a misshapen splodge when you rub off the masking fluid.

- It is important to use a brush with proper hairs. It can be an inexpensive synthetic one, but it must have a decent point. A No. 2 or 3 is ideal.

- Coat your brush with soap before dipping it into the masking fluid and rinse it out immediately after use to keep it clean and usable.

- Colour shapers are convenient to use as they are easily cleaned by simply rubbing away the fluid. A size 1 is very good for fine lines, such as stamens on flowers.

- Put down a good layer of the fluid. The point of masking fluid is to isolate the part you do not want covered in paint, so a good thickness is essential. It is also easier to remove when laid quite thickly.

- Many painters say that the fluid can lift off and spoil the surface of the paper, which can completely ruin a painting. This will not happen if you make sure the paper is completely dry before use. Use the correct side of the paper.

- If you have dampened the paper in order to stretch it, then make sure there is no moisture left in it before applying masking fluid.

- Make sure everything is dry before rubbing off the masking fluid.

Snowdrops and Fallen Leaves

23 x 23cm (9 x 9in)

This picture of snowdrops shows how useful masking fluid can be in keeping areas clean and white, allowing you to paint pictures with striking contrast.

16

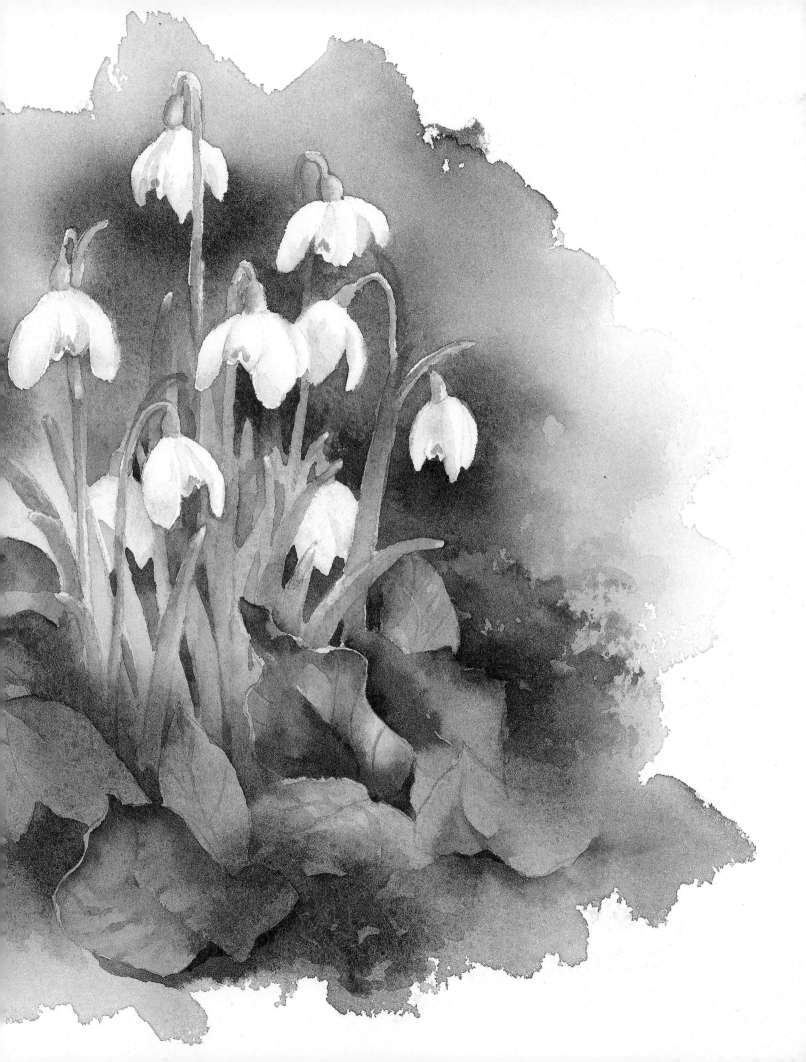

WILD FLOWERS IN WATERCOLOUR

by Wendy Tait

Painting wild flowers can be quite a challenge, for many reasons. Many of them are very small and delicate, which means that they are more 'fiddly' to paint than cultivated flowers. This means that they need closer study before you begin to paint, and that the paintings take longer to complete. It does not mean overpainting, however. Quite the reverse! Wild flowers need a subtle, delicate touch to complement their fragile beauty.

Another challenge faced in trying to capture wild flowers is that, ideally, they should be painted *in situ*, especially if they are not the common varieties like daisies or buttercups. Picking wild flowers means that there will be fewer seeds to be spread, and fewer flowers to be enjoyed by others the following year. In many areas, picking wild flowers is actually illegal. Luckily, it is now possible to buy wild flower seeds and plants to bring into our own gardens, providing easily-accessible subjects for painting and helping to ensure that they are not lost to future generations. Many species are already losing the battle with modern life and methods of farming which threaten our hedgerows.

Painting out of doors also means that you have to contend with the elements, which can lead to awkward situations. It is often too hot, cold, windy, sunny or rainy, but it is all part of suffering for your art, I believe!

Research will improve your painting. Study carefully the way your flower grows, the way it is attached to its stem and the way the leaves grow. Know whether its habit is to ramble, to stand straight or to form a bush. If you are picking the flower to take indoors, look around you first. Look at the sky: is it a misty or a sunny day? Do you want this mood in your painting? Try to feel the atmosphere of the area. If you were sitting outside, all of these elements would affect the way you painted. I feel that it is more important to capture the feeling of the flowers and their environment; the colours, the wind, the season, than to produce an accurate botanical study.

Despite all the potential problems, I still love to paint these fleeting treasures. I defy anyone exploring the countryside not to experience an enormous uplifting of the spirits at the sight of a bank of primroses, a bluebell wood, a swathe of poppies or a bush of wild roses in full bloom. These are the times when I am so glad that I am a painter. I sometimes wish I was a poet too.

Opposite
Summer Days
I asked permission at a local farm, then picked this bucketful of flowers from their fields.

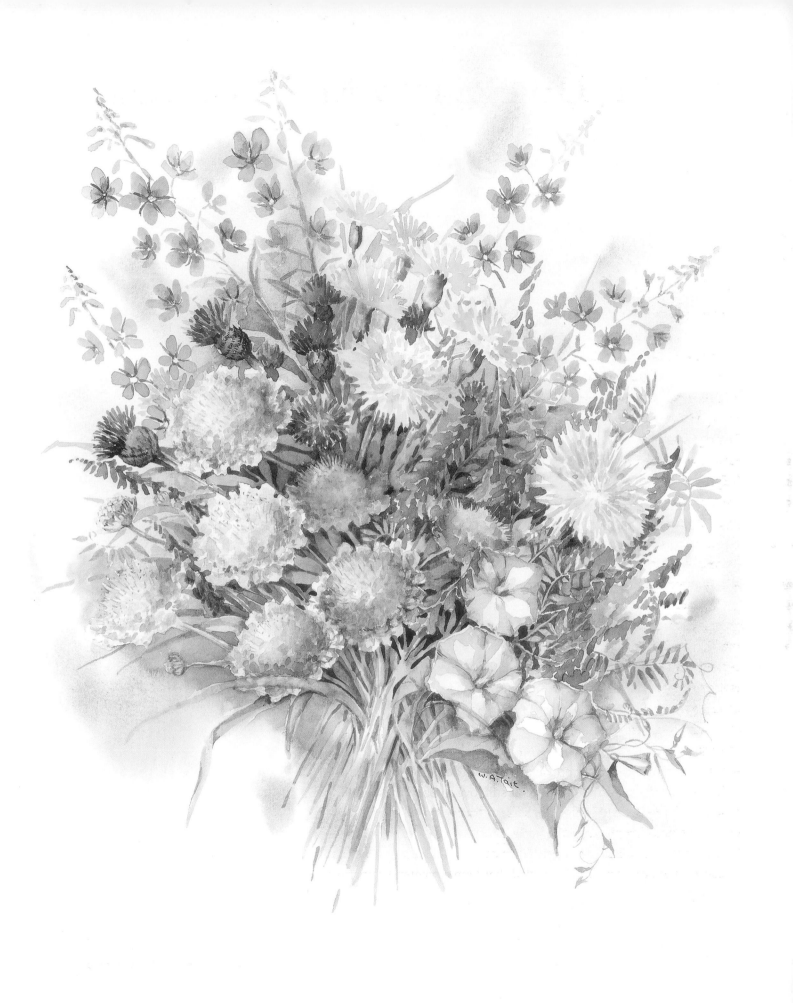

Colours for wild flowers

Over the years, I have listened to friends and students as we are painting together. It is wise to keep an open mind about materials and equipment; often, you can be introduced to something new and exciting. I love getting together with painting people and swapping ideas. Someone else's experiment with colour can be extremely refreshing, and can set you off in a new direction. A little of what they are using, alongside your own colours, can sometimes add an extra dimension to your painting.

I have used a basic 'green mix' of Winsor lemon and Payne's gray for many years, but nowadays I will often add a little indigo. To produce a warm, dark green, a mix of indigo and quinacridone gold is very good.

I have recently cut out raw sienna and new gamboge, as I find that I can mix beautiful yellows with Winsor lemon, gold and a touch of orange. Scarlet lake and ultramarine violet have also been banished from my palette. I find I can easily mix all the reds, pinks and violets I need with what I have left. I have, however, added ultramarine blue, which I find gives me a warmer, more intense blue.

My palette
Cobalt blue deep
Ultramarine blue
Winsor violet
Brown madder
Winsor orange
Quinacridone magenta
Quinacridone gold
Permanent rose
Payne's gray
Winsor lemon
Indigo

Winsor lemon
Quinacridone gold
Indigo

Winsor lemon
Payne's gray
Quinacridone gold

Winsor Lemon
Cobalt blue
Payne's gray

Winsor lemon
Winsor orange
Quinacridone gold

Winsor lemon
Brown madder
Winsor violet

Cobalt blue
Winsor violet
Quinacridone magenta

Quinacridone gold
Brown madder
Winsor violet

Brown madder
Ultramarine
Winsor violet

Permanent rose
Quinacridone magenta
Winsor violet

Cobalt blue
Ultramarine
Winsor violet

Winsor orange
Permanent rose
Quinacridone magenta

Winsor lemon
Cobalt blue
Winsor violet

Planning your painting

This is the most important stage. Whether or not you begin by using a little pencil – I prefer not to – make sure you allow plenty of thinking time. This is something you learn with experience. The beginner will often be desperate to make a start, and will jump in without thinking, or will be panic-stricken at the sight of fresh white paper and lose concentration. The answer is to study and plan out your composition in your head, as I do. If necessary, make a small 'doodle' of your idea on a piece of scrap paper.

Study the flowers well before you begin. Choose one flower, or a group that you like particularly, and begin to build your painting from there. Your main group of flowers, or focal point, should be larger than those surrounding them, and should usually be positioned fairly low on the paper. As you complete your painting, your composition can always 'grow' outwards from this point. Half-close your eyes when looking at the subject, so that the details disappear. Think of your flowers as light or dark shapes, and try not to make things too complicated.

I sometimes think that when I encourage them to dispense with a pencil, I am making it very hard for my students. Those who are brave enough to try must have an idea of what they are aiming for, and I know it may sometimes appear, wrongly, that I have no plan. A common mistake, when starting a wet-in-wet background, is to drop in colours haphazardly. I have a clear picture in my mind of where the colours are going to go before I begin.

I often like to make my main flowers the lightest in tone, so that contrasting darks can be slipped behind them in the final stages to make them stand out.

Summer Meadows

Negative painting behind the white daisies and clover shows the focal point in this painting. The flowers that are further away are far softer in colour and tone.

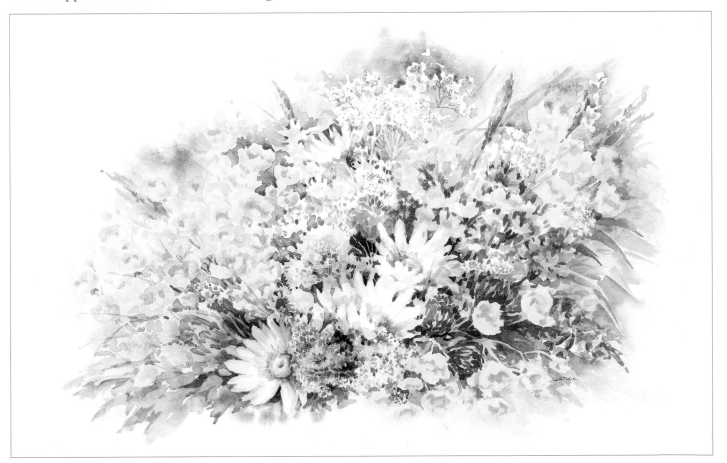

Composition

When planning a composition, I use my imaginary dotted lines (see below), and make sure that my focal point is at the approximate point where these lines cross. This is not imperative, but it often provides a guide to good composition. A successful painting has a detailed focal point, with everything else taking second place. Sometimes you will want to emphasise one flower, or a group of flower heads, and the flowers in the background should be misty and diffused. Look at your subject, pick out what you most like about it, and make this your focal point.

In a good composition, the lines of the main flowers can be echoed in the background flowers, which helps to carry the eye through the painting. It is also a good idea to restrict the number of colours used: when many brightly-coloured flowers vie for attention it can spoil the overall effect. Ask yourself questions all the time: 'What do I like about this subject?'; 'Do I really want to paint all I see?'; 'Is there a particular flower that attracts me most?'; 'Which viewpoint do I prefer?'

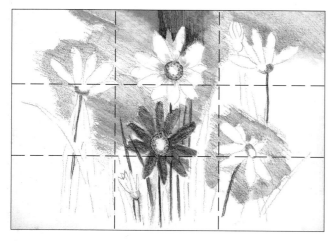

Example 1

This composition is not ideal. The flowers are too central and form a dividing line. The dark flower does not work against the background grasses: whatever its colour, it would have collected some light which would cause a shadow behind it.

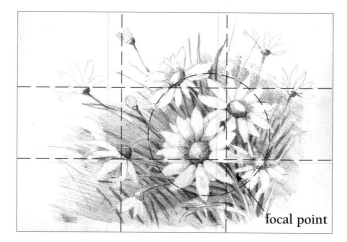

focal point

Example 2

This sketch works far better, because the flowers are grouped off-centre and the largest is the lowest. The background grasses are darker, which has the effect of highlighting the flowers.

Troubleshooting

These points may help to solve some common problems:

Q How do I find my focal point?

Try starting with the flower, or group of flowers, at the intersection of your imaginary lines.

Q Why are my flowers too near the top of my paper?

Always begin the painting towards the bottom of the paper with the largest flower and work outwards.

Q Why do my stems and leaves look too dark?

Think of stems and leaves in negative. They are round, and collect light. Paint the darks around them for a more natural effect.

Q How do I prevent a 'halo' effect round my flowers?

Take the water far beyond where you want colour, often right to the edge of the paper. Drop in colour behind the flower, tipping the paper so the colour disperses, leaving no hard edge.

Foxgloves

I saw these foxgloves growing by a hedge, and moved the daisies much nearer to achieve a good composition. Note how the eye is drawn to the daisies and travels up the curve of the foxgloves. This is because the darkest darks, behind the lightest lights of the daisies, act as a focal point. Colours used were Winsor lemon, Winsor violet, quinacridone magenta, cobalt blue and a green mix made from Winsor lemon and Payne's gray. I used masking fluid on the daisies.

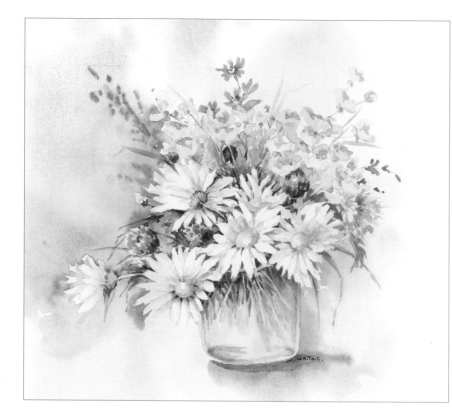

In a container
Flowers in a jam jar

I occasionally paint flowers in a container, but I am always far more interested in the flowers. I make sure they always take centre stage and keep the container very simple. For this picture, I used Winsor lemon, quinacridone gold, quinacridone magenta, Winsor violet, cobalt blue, and a green mix made from Winsor lemon and Payne's gray.

Hand-held bunch
Wild flower bouquet

To paint the flowers in a bouquet, you must remember that all the stems should come together to suggest that they are held in your hand. Notice that the cow parsley at the back has been painted in negative, using 'sky holes' of background colour to show the shapes between the stems and the almost-white flowers. The colours used were the same as in the painting above.

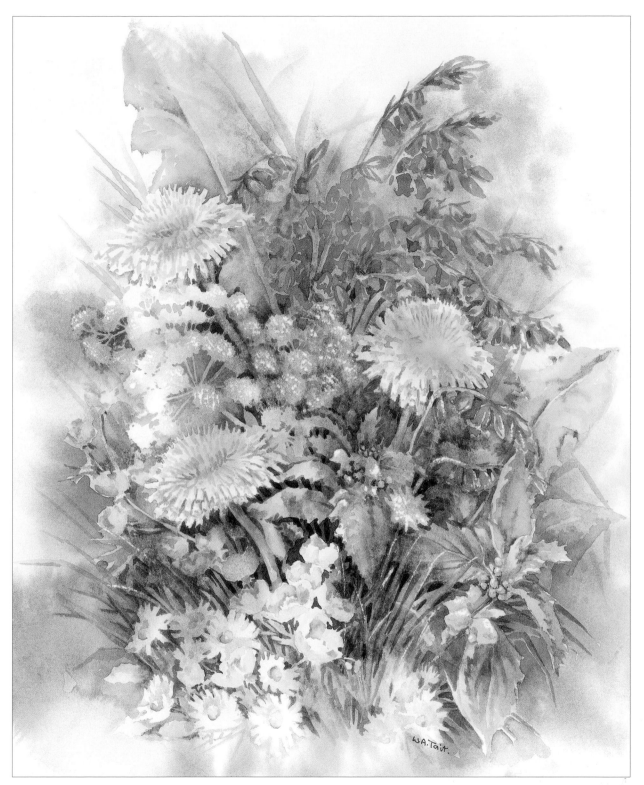

Growing wild

In the Hedgerow

I just managed to rescue this painting after doing something that is all too easy – putting too many darks in the initial background wash. The result was larger areas of deep tones than I wanted, and I had to go in very dark with my small contrasts. I also did something I rarely do: scratched out one or two highlights with the point of a small knife. This must be done very carefully, or you end up with a hole in the paper. Another option is to use white gouache, but I avoid this as it can look clumsy.

Sketching

Although I love colour, I sometimes like to draw, and enjoy the exercise of a purely tonal painting. I also like to use a pen and wash technique, drawing first in a sepia pen, which is not as harsh as black, then adding a little colour wash. I find that different subjects dictate variations on this theme, especially if you have very sculptured flowers such as foxgloves, bluebells or harebells.

Sometimes, when you have been struggling with the complexities of watercolour, it is restful to try something different. Making a little sketch on a piece of scrap paper before you embark on a watercolour painting can also help you to understand tonal values. In my classes, we often divide the paper in two and draw the subject with a water-soluble pen on one half, then paint in watercolour on the other half, using the brush straight on the paper – no pencil outlines. When painting an individual flower, take one petal or section at a time. Many students try to go round all the petals at once. You need to study the shape of each petal before you begin, and I am sure you will find it easier to paint each petal separately. Use the whole brush, not just the point.

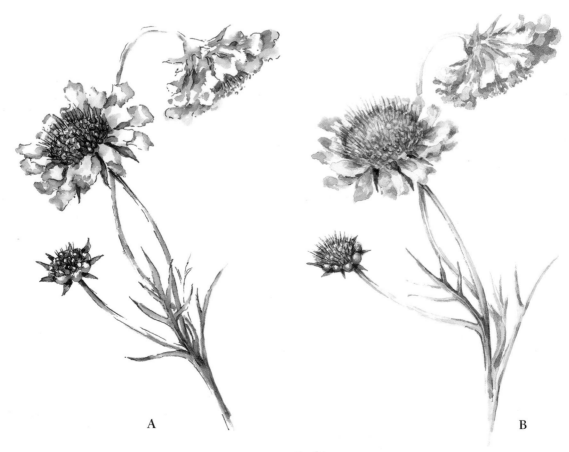

A B

Scabious
The same flower has been first drawn in water-soluble pen (A), which
helps to identify the light and dark tones before going on to use colour.
Then, in a separate study, it has been painted in watercolour (B).

Water-soluble pen

These pens are inexpensive and are very satisfying to use. Begin by drawing the flower very lightly, using broken lines occasionally to prevent it becoming too heavy. Take a small brush, No. 1 or No. 2, and dip it in water. Roll it on a piece of rag to remove any excess water and follow the drawing on the shadow side. You can then use the shadow as you would if you were working in watercolour. Gauging the amount of water you need will take practice.

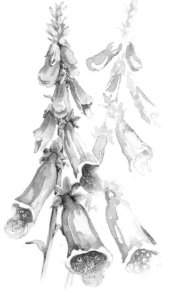

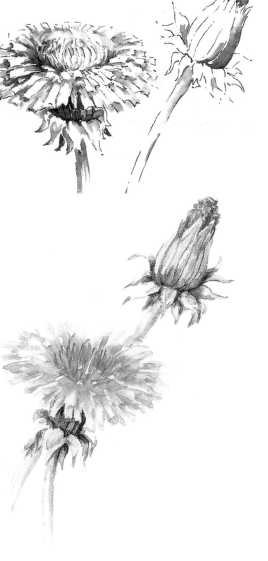

Watercolour

Keep the tones very pale to begin with. Draw with your brush, using a No. 6. Allow your work to dry, then make a stronger mix of the same colours and use it to add details and contrast. This is where you can adjust any shapes that may not have worked out in the paler wash. I prefer to use a No. 1 or No. 2 brush for these smaller flowers.

Leaves

Leaves are often neglected, which is a pity as they are beautiful in their own right. It must be remembered, though, that they should enhance rather than take attention away from the flower.

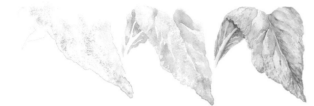

Foxgloves

Buttercup

Clover

Ivy
It is more effective visually not to take every leaf to the same degree of finish.

Grasses
Used behind wild flowers, grasses give a composition interest and form. I used a No.1 brush and very dry colour to add the tiny, thin lines.

Primroses and dandelions

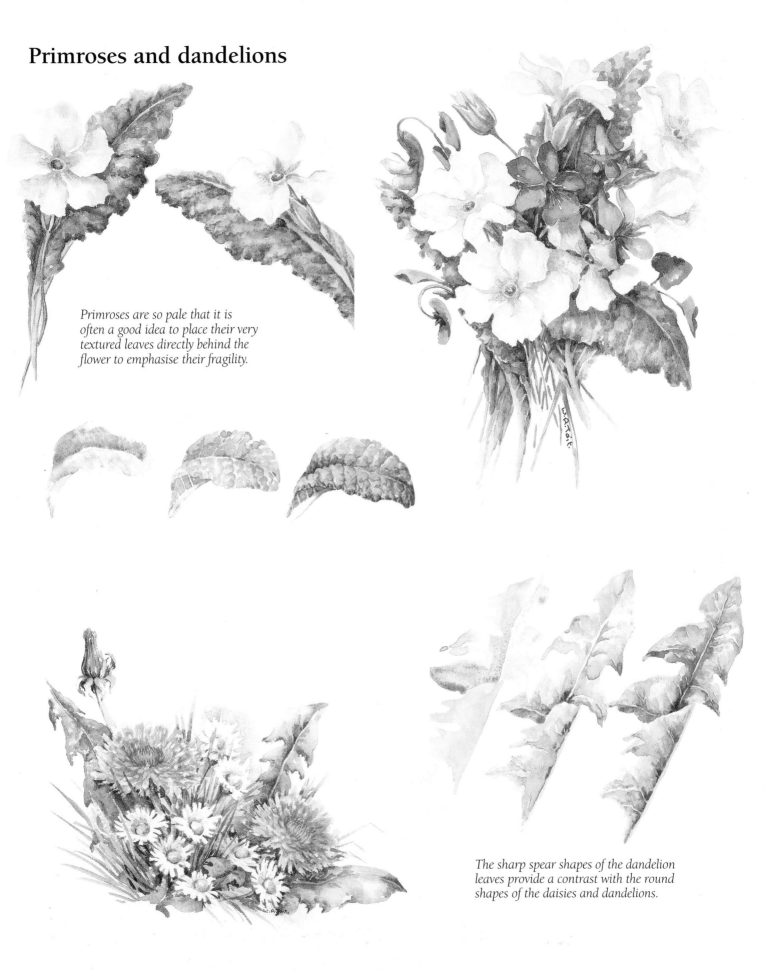

Primroses are so pale that it is often a good idea to place their very textured leaves directly behind the flower to emphasise their fragility.

The sharp spear shapes of the dandelion leaves provide a contrast with the round shapes of the daisies and dandelions.

Painting backgrounds

The technique I use to create my backgrounds takes time and plenty of practice, but it can be great fun, and you can achieve some wonderful effects. At first, it is better to err on the side of soft colour than to make it too strong, as the colour can be strengthened at a later stage. Do not forget that your work will dry lighter. Experiment on the reverse of a discarded painting; if you are anything like me, you will have many. The colour should be dropped off the point of the brush: do not be tempted to paint at this stage.

The technique

Start by wetting the paper thoroughly right to the edges, leaving no dry areas. Wait a short time until the shine begins to go off the surface of the paper, then drop in the colours, using a No. 12 brush. The colours must be near enough to each other to fuse or run together. Tip the paper in different directions to make this happen, but guide the colour away from your main point of interest. At the same time, remember to leave light areas which will be used for highlights.

Tip
- *If too much colour gathers at the main point of interest, it can be lifted out or blotted away, but it is best to try to avoid this.*
- *If the colour runs too much, you are using too much water.*
- *If the colour does not run enough, add a little more water to the colour in your palette, not to the paper.*

Sample background
I left white spaces for the roses I planned to paint on this background. I dropped in blue (cobalt blue deep with a touch of Winsor violet) next to the yellow (Winsor lemon and quinacridone gold) so that it would merge slightly. Winsor violet was dropped in last, again right next to the other colours, to indicate the position of the background shadow.

Finishing the background

When you have completed your flowers, return to the background, which by now will have dried and may look very pale. You can drop in deeper colour behind the flowers immediately if you feel that the background is not strong enough, but remember to wet the paper right to the edge, then drop the colours into a small area only. Work on a small section at a time and allow your work to dry before moving on to complete the next section. Clear water can be applied to the paint without risk of the colour lifting, as long as it is allowed to dry between applications. Do not 'worry' at the paint while it is still wet: therein lies disaster!

Always cover a far larger area than you feel is necessary with water, and do not let the paint flow as far as the edge of the dampened area. Paint flow can be controlled quite easily by tipping your surface towards the flower to deepen the intensity of colour in the area behind it.

Try dropping in one colour, say blue, and after tipping it add a slightly stronger mix of another colour, say violet, and allow them to mingle. This can also be done effectively with a green mix. To avoid watermarks, remember that each time you put paint on, it must be a little thicker than the time before.

Wild roses

This example below was painted on a background very similar to the example on the facing page. The flowers were painted where I left spaces. When I had painted the leaves and the buds, I reinstated small darks behind them. I dropped in a blue sky shape between the 'negative' white shapes, which suggest more flowers.

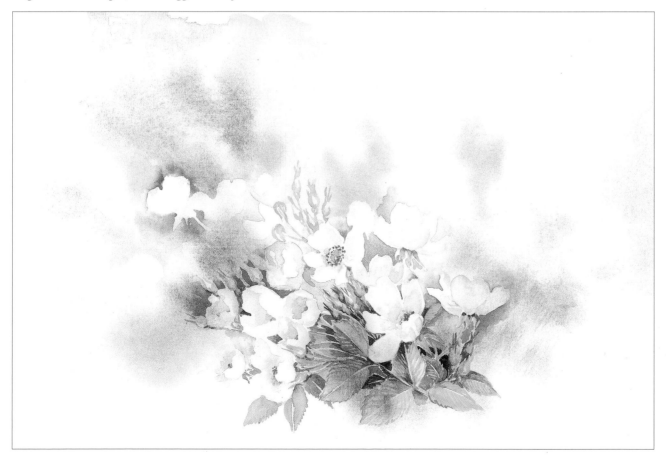

Masking fluid for painting backgrounds

For the example below, I applied masking fluid in 'daisy' shapes, let it dry, then dropped in the background colours. Wet the paper right over the masking fluid and follow the instructions for backgrounds on page 30. When everything is absolutely dry, rub off the masking fluid gently with your finger. The negative shapes can then be painted between the grasses, and a little shadow added to the daisies using a pale wash of cobalt blue with a little green mix (Winsor lemon and indigo) added. Add the centres of the daisies using quinacridone gold and put in the shadows with the same blue and green mix.

In the painting below, I have taken some daisies to a finished state by putting in the darks behind them, and left some to show the stages of light, medium and dark tones. Note that the darker the tone, the smaller the area painted.

__Unfinished field flowers__
With masking fluid.

Negative painting

There is a theory that white flowers are difficult to paint. This is not true at all: white flowers take very little painting. All the painting goes on behind them and around them: lots of negative painting and very delicate shadows on the flowers themselves.

I have used the same background technique for this painting as for the one opposite, but leaving 'highlight spaces' for the lightest flowers. This gives a softer effect. Remember that you should paint negative darks *behind* the flowers rather than painting the actual flowers. After painting the clover and the buttercups, go back into the pale flowers with a little shadow, and put in the centres.

Unfinished field flowers
Without masking fluid.

Negative flowers

With masking fluid

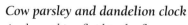

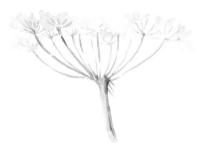

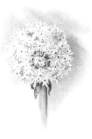

Cow parsley and dandelion clock

Apply masking fluid to the flower heads, using little star shapes for the dandelion clock.

Remove the masking fluid and paint the details on the shadow side of the flowers. Darken the shadow side of the stem.

Without masking fluid

Cow parsley

Paint the positive shapes of the stems and under the flower heads directly on to the paper. Wet a large area round the flower, avoiding the flower heads.

Paint between the stems with the background colour, leaving white highlights on the light side. Let it dry, then paint details on the shadow side.

Dandelion clock

Paint the shadow side with a mix of pale green/ blue. Let it dry and add details with star shapes, adding stronger colour on the shadow side. Wet a large area round this, leaving white highlights all round the clock, and while the paper is wet drop in background colour. Tip the paper to move the colour about.

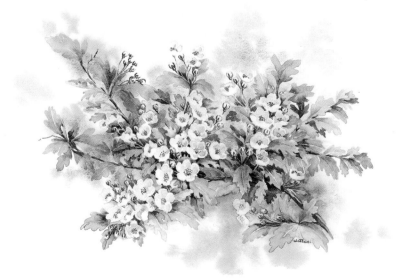

Hawthorn

This study shows negative flowers against dark background leaves. The strongest contrasts — the lightest lights and the darkest darks — are concentrated around the focal point.

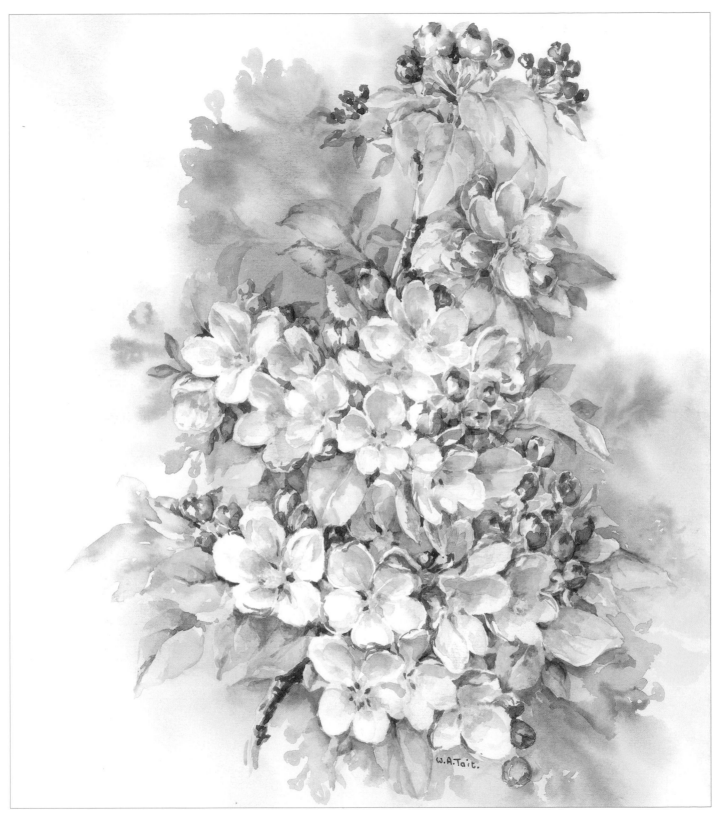

Crab Apple Blossom

I know where to find these small trees in my local fields, and I paint them in bloom almost every year. Again, the apple blossom depends heavily on the tiny darks between the leaves to show up the white and pink blossoms, which are painted in negative. If you paint the leaves a mid-toned green you can add a darker green made from indigo and quinacridone gold to really sharpen up the image in the shadows.

Honeysuckle Spray

This is a simple study, painted directly on to the paper. I have added a little background colour at the end, but you could leave this out if you wish. I do not think a tonal sketch is necessary for such a simple subject. Do, however, spend time studying the subject well before you begin. Note how the crown shape of the flowers radiates from the centre, the way each petal opens to show the inner gold, and the way the stems curve. Note that the leaves fold around the stem.

Remember that you are trying to achieve an impression, rather than a slavish copy, of your flowers, so you can use 'artistic licence' to adjust the finer points. Take the flowers out of the jar, look at them from different angles and paint the view of each that you like the best.

You will need

Watercolour paper 300gsm (140lb)
Brush: No. 6 round
Watercolour paints: Winsor lemon, brown madder, ultramarine, magenta, cobalt blue, indigo, quinacridone gold, Winsor violet, permanent rose

Before you begin, mix the main washes:

1) Winsor lemon and permanent rose (creamy yellow)
2) Quinacridone gold with a touch of magenta (deeper yellow)
3) Winsor lemon and quinacridone gold with a touch of indigo (green)
4) Permanent rose (pale pink)

The flowers on which I based my painting.

36

1. Using a No. 6 brush and the pale creamy yellow wash, put in a few marks to locate the shape of the flower. Change to the permanent rose wash and put in the petals, remembering that each petal should radiate from the crown of the flower. Rinse your brush and soften the effect using plain water.

Tip

Always begin with pale tones, adding darker ones when you have established the lights.

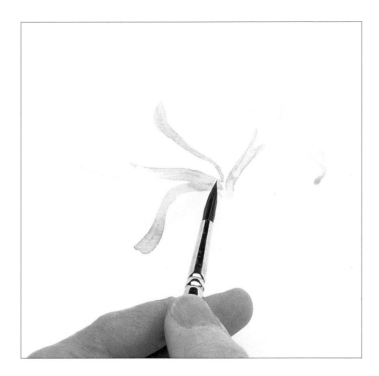

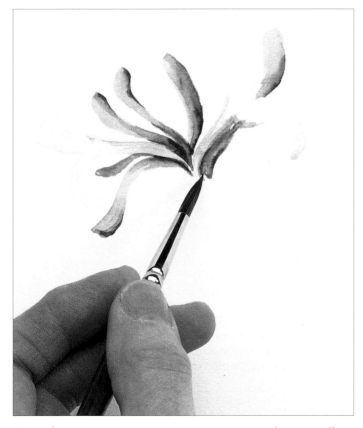

2. Make a stronger permanent rose mix and put in all the main flower buds, making sure they meet at the same point. Use a little magenta mixed with brown madder and a touch of Winsor violet for the shadow side, noting that the light is from the left.

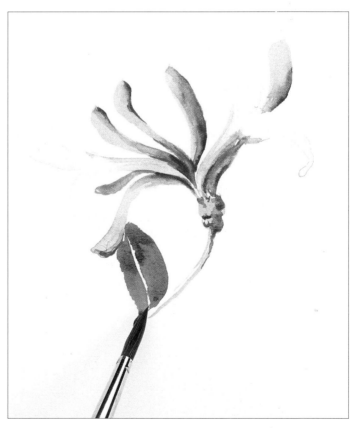

3. With pale green made from Winsor lemon, quinacridone gold and a touch of indigo, put in the base of the flower. Add the tones using a mix made with a deeper concentration of the same pigment. Put in the first leaf with the same colours.

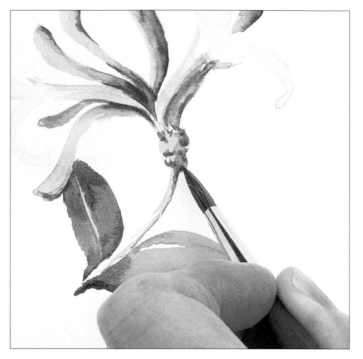

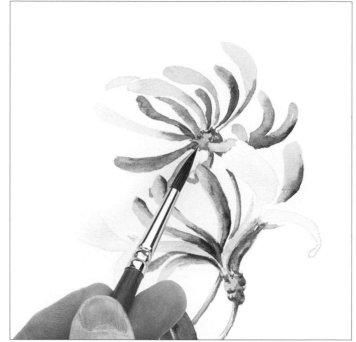

4. Put in two more leaves using the same colours, and adding a little ultramarine into the shadow side of both leaves. Reserve a fine line of white paper for the spine of the leaf, then tone it down by brushing a touch of water over it to take off the starkness. Add some very dark tone made from quinacridone gold and indigo to the base of the flower.

5. Add another flower, remembering that the petals of each bloom must radiate from the same central point. Use slightly darker tones of paint from the edge of the colour on your palette. The concentration of pigment is more intense where the flower passes behind the one in front. This helps to make it stand out. Add the stem in green.

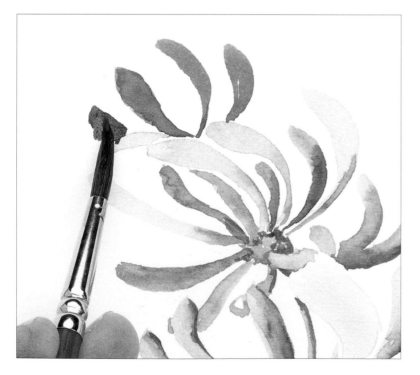

6. Increase the concentration of pigment in the pink mix and add a darker flower behind the last flower you painted. Each petal is done with one brushstroke, laying it on the paper and lifting it off.

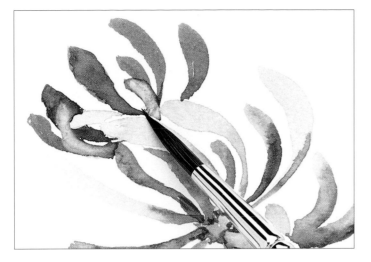

7. Mix in a tiny quantity of Winsor violet and add the darks on the shadow side of the flower.

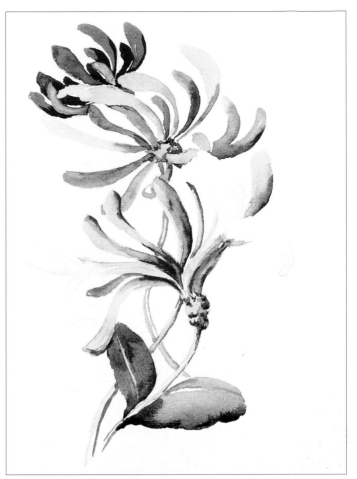

8. Look at the balance of the whole picture. In this case, the composition needs some more detail on the right-hand side to balance it out.

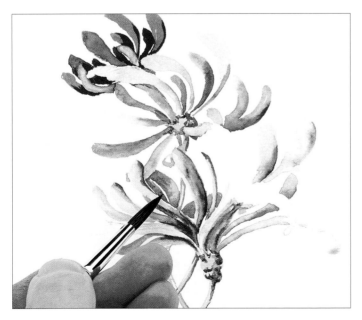

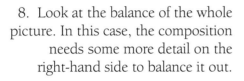

9. Add more fullness to the main flower, and some more leaves with green mix.

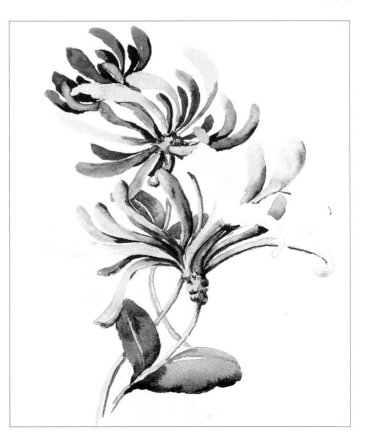

10. Build up deeper tones across the whole painting, making sure your brush has a good point.

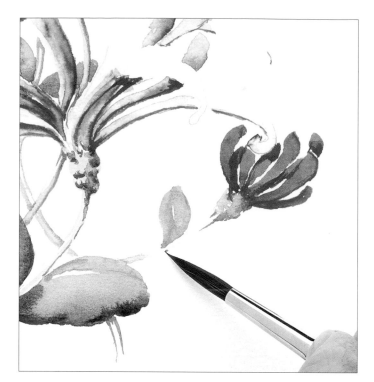

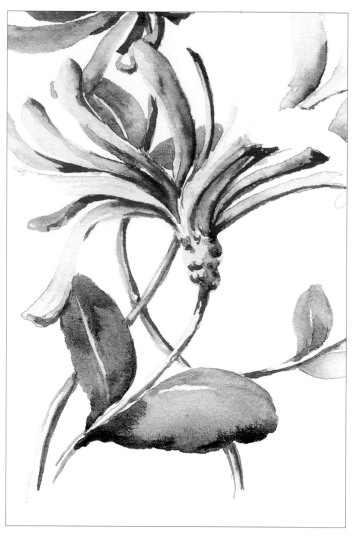

11. Add a small, dark bud at the bottom right to balance the composition. Put in the stalk, and a tiny leaf to stop the gap looking too big.

12. Work across the whole painting, adding magenta to the stems and to the shadow side to tie it all together.

13. Add tiny details to the light flowers using quinacridone gold, then wash with clean water to soften the effect. Add tiny, very dry touches of violet in the shadows. Add cool shadows to the edges of the gold petals, where they are very thin, by touching the edges with a weak wash of cobalt blue.

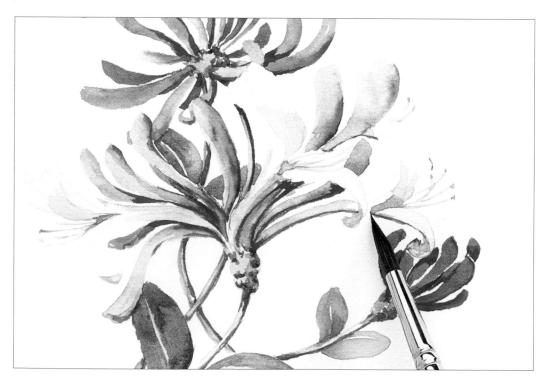

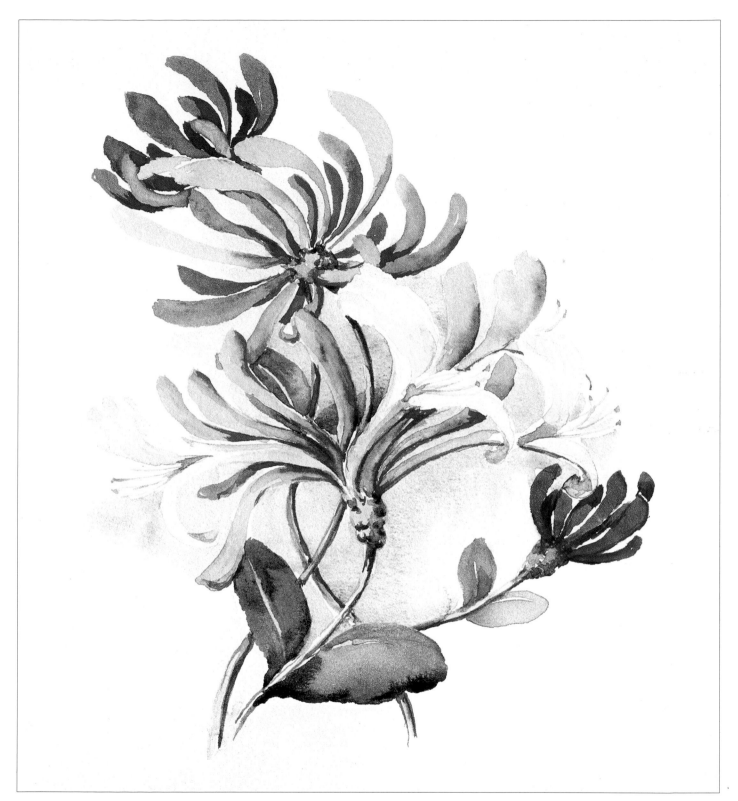

The finished painting

The area between the flowers and leaves was wetted using a lot of water, taking the water well away from the coloured area. A little cobalt blue was dropped in and allowed to disperse.

Wild Roses

The second project introduces a coloured background which makes a picture of the subject instead of just a study. I drew the roses with a water-soluble pen on a separate piece of paper before I began, to familiarise myself with the different tones. I began the painting on a fresh piece of paper, and started by dropping in the background.

You will need

Watercolour paper 300gsm (140lb)
Brushes: No. 12 round, No. 6 round and large hake brush
Absorbent paper or rag
Watercolour paints: Winsor orange, quinacridone gold, permanent rose, cobalt blue, Winsor lemon, magenta, Winsor violet

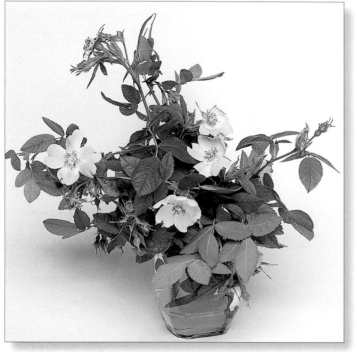

The bunch of wild roses I used. If you cannot find many roses, turn the jar and use the same flower from a different angle.

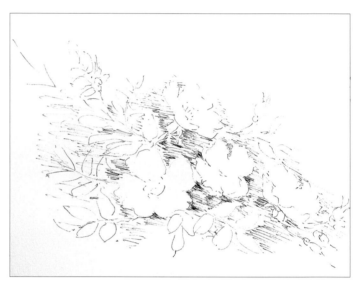

Rough sketch in water-soluble pen, for guidance only.

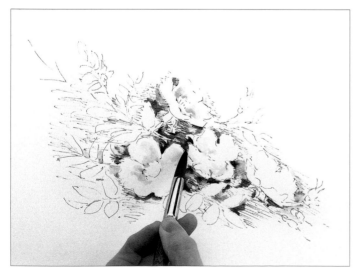

Make a sketch in water-soluble pen and add water to intensify the tones. This is for use as a tonal plan, not for painting.

Before you begin, mix the main washes:

1) Quinacridone gold and Winsor lemon (yellow)
2) Permanent rose (pink)
3) Cobalt blue deep with a touch of Winsor violet (blue)
4) Winsor lemon, quinacridone gold and indigo (green)

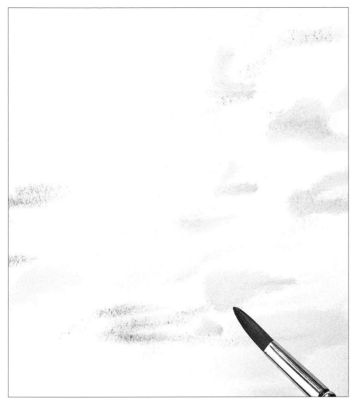

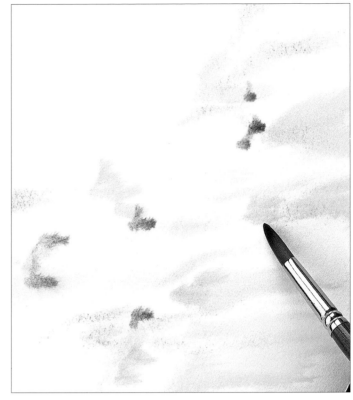

1. Wet your paper using a large hake brush and sweeping strokes. Change to a No. 12 brush and immediately start dropping in background colours.

2. Tip and rotate your paper as you continue to add in the background colours, so they mingle and spread to form interesting shapes.

3. If any colour has run into the reserved highlights for the main flowers, dab with absorbent paper or rag to remove it.

4. Change to a No. 6 brush and put in the roses using a pale mix of permanent rose and Winsor orange. For a smooth result lay the whole brush, not just the point, on the paper. Where the tones are deeper, increase the concentration of the pigment. Do not worry if you go over some of the green or blue areas. Note how the dark blue splodge in my painting is used for the darks behind the flowers.

5. Make a fairly strong wash of quinacridone gold and put in the centres of the flowers. Add a spot of green mix wet-in-wet for the centres and shadows.

6. Paint in the sepals using the green wash, then add extra pigment in the mix to make a medium toned green and add the shadows, wet-in-wet. Paint in the stems, keeping them fairly short at this stage in case you want to add more flowers later.

7. Re-wet the areas round some of the flowers and drop in tones of the medium green for the foliage. Mix a slightly deeper green with Winsor lemon, indigo and quinacridone gold and use this to drop in slightly darker tones right next to the flowers.

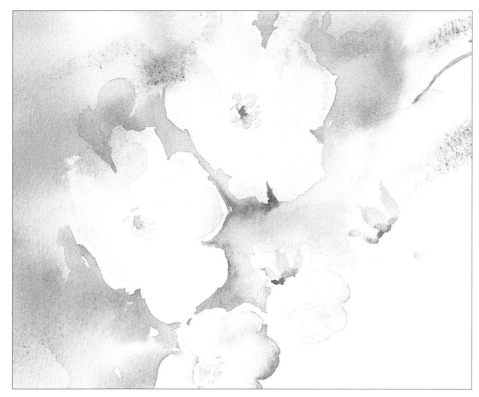

8. As you add the darker background tones, leave a narrow line of white paper on the edge of each petal where it catches the light. This will help the flowers to 'stand out' from the paper.

9. Dampen the painting round the outside flowers, taking the water right to the edge of the paper. Add in cobalt blue with a touch of violet and let it run, then add a touch of green mix and let it run, tipping and turning your work to achieve the desired effect.

10. Work round your painting, concentrating on small areas and improving on your 'drawing' as you go. Put in the shadows behind the petals with a blue mix made from cobalt blue and violet.

11. Add some of the flower buds using a pale green mix of Winsor lemon and indigo. Strengthen the concentration of pigment in the mix and put in the shadows, remembering where the light is coming from.

12. Mix a deeper pink with a touch of Winsor orange and add buds where necessary, leaving a very fine white line round the green parts of the bud. Increase the pigment in the green mix and put in the shadows of the buds.

13. Add touches of pink on the shadow side, and re-define the stamens with gold. Use a mix of cobalt blue and Winsor violet to define the centres. Drop in a little green mix by the stamens, and let it bleed into the blue.

14. Make a deeper green from Winsor lemon, indigo and a touch of quinacridone gold. Use it for negative painting behind the leaves, studying the flowers to see how the leaves grow. Soften off some outside edges with water.

15. Add the leaf detail, painting the halves of each leaf separately and dropping in a little darker colour on the shadowed side. Always mix in violet or blue to shadow green, never Payne's gray or indigo. Add the fine lines on the leaves.

16. Continue to build up detail, remembering that to give depth to your painting some leaves should be seen only partially and in shadow. These will not show any detailed fine lines.

17. Work over the painting, adding tiny touches, sharpening up details and softening edges with a little water where necessary. Stop before you begin to 'fiddle'.

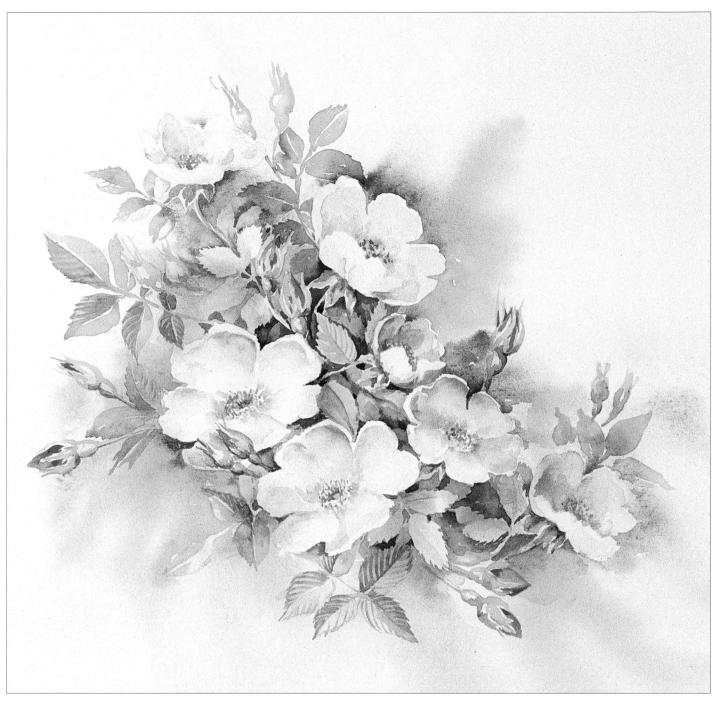

The finished painting

When working over the painting, always bear in mind that the darkest darks go behind the lightest lights and vice versa. I have also added a couple of buds in front of one of the flowers to make the overall effect more natural.

Wild Flowers

The final project in this chapter is a bunch of wild flowers in my favourite pinks, violets and blues. Daisies give a pale focal point, and leaves and grasses provide the contrasts. It is quite loosely painted, as I feel it suits the wild subject.

I sometimes sketch out the tones and shapes of the composition, as seen in the drawing (below right). Do not forget that this drawing is for reference only and is not to be used in the painting.

You will need

Watercolour paper 300gsm (140lb)
Brushes: Nos. 12 and 6 round,
Large hake brush
Watercolour paints: cadmium lemon, quinacridone gold, Winsor violet, permanent rose, indigo, cobalt blue, magenta, brown madder

The flowers I used.

My outline sketch.

Before you begin, mix the main washes:

1) Winsor lemon and quinacridone gold (yellow)
2) Winsor lemon and indigo (green)
3) Winsor lemon/ indigo as above, but with more water (pale green)
4) Cobalt blue and Winsor violet (blue)
5) Permanent rose and magenta (pink)

1. Use a large hake brush to wet the whole of your paper. Mop the lower edge with absorbent paper so excess water does not seep up and spoil the washes.

2. With a No. 12 brush, scoop up a good quantity of yellow wash mix and sweep it across the paper. Rinse the brush and drop in a sweep of blue mix.

3. Add some of the pink wash mix right next to the blue, and let the colours run down, then repeat the process with the pale green wash.

4. Hold the painting at a different angle, then add some more blue wash mix and let it run down. Tip the paper quickly so the colours do not run over each other; the desired effect is for them to merge slightly.

5. Build up the areas of paler and darker washes, letting the shades run and merge to produce a soft background.

6. Lay the painting flat. If any colour has run into an area you want to reserve, lift it out with a clean, dry brush or some soft tissue if you prefer. Leave to dry.

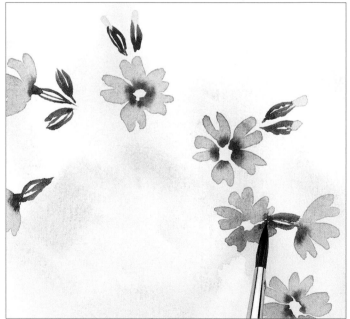

7. Change to a No.12 brush. Add more pigment to the pink mix and put in the campion petals. Deepen the pigment again and put in the centres wet-in-wet, letting them bleed into the petals. The background will be almost dry by now and you can begin the detail.

8. Change to a No. 6 brush. Mix up a pinky-brown using brown madder and violet and put in the leaves and buds. Lift out any runs with a clean, dry brush.

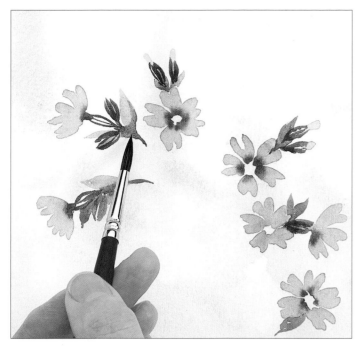

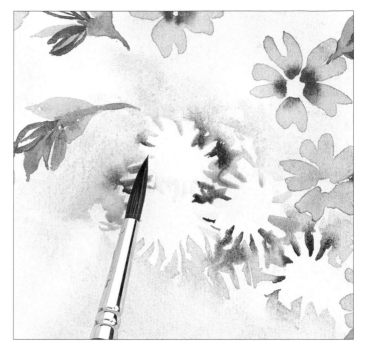

9. Add green mix to the leaves. Put in short lengths of stem, but do not take them too far as you may want to add another flower later. Darken the green with a little of the pinky-brown and add the shadows and darks, letting the darks run a little wet-in-wet.

10. Painting in negative, wet the area down to where the white flowers are to be, taking it behind the flower shapes. Drop in some blue round the flower shapes, then drop some green into the wet blue.

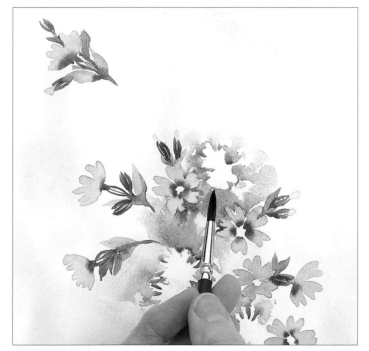

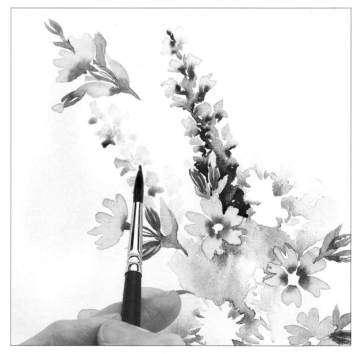

11. Do the same again, dropping in blue and green wherever you need contrast to show up a pale flower.

12. Paint the bugle flower on the right with a pale mix of cobalt blue and violet. Drop in the green stem, letting it bleed, then as that dries drop in the violet. Repeat for the second bugle flower.

13. Add a few more campions on the yellow area on the right of the painting, using exactly the same tones as for the ones put in earlier.

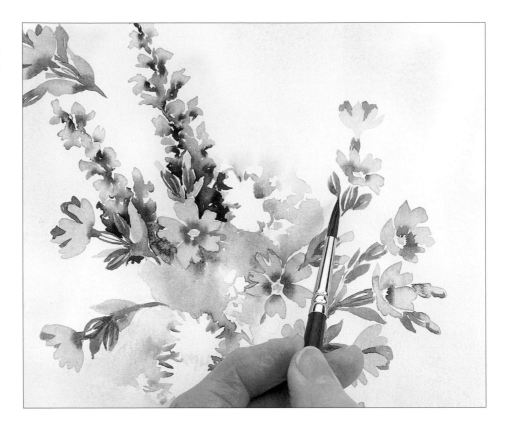

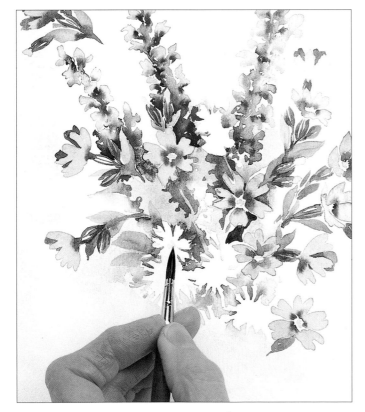

14. Painting in negative, continue dropping greens and blues in deeper tones behind the paler flowers. Ultramarine and violet make a good intense blue just behind the campions. Add the daisy centres in green.

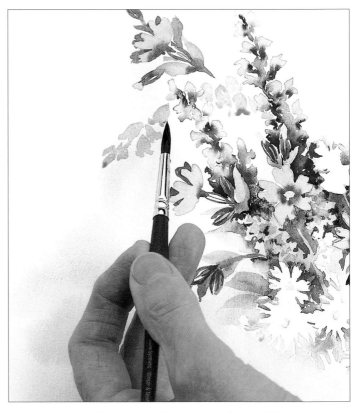

15. Paint any flowers on the outer edges of the bunch, making sure that they are paler than the ones in the centre.

16. Wet the flowers with clean water and add darker tones to the shadow side.

17. Paint the leaves in two sections to show light and shade.

18. Mix darker green from quinacridone gold and indigo and use it to paint in negative behind some stems. Make another mix of cobalt blue and violet and do the same to suggest background.

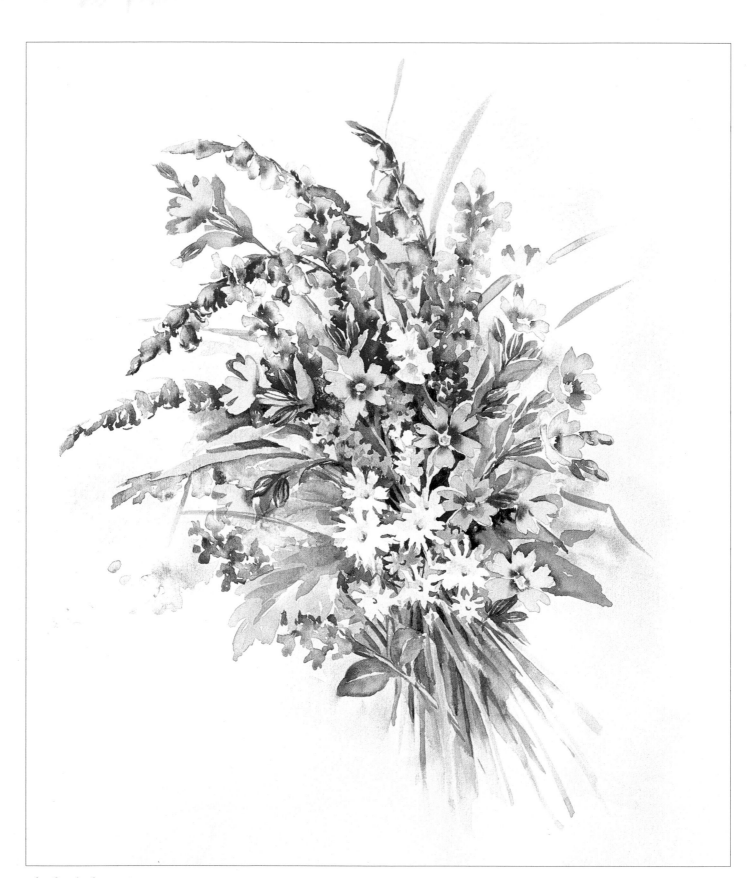

The finished painting

*As usual, I have placed the pale flowers low in the composition
so they have the darkest leaves for contrast.*

Poppies and Daisies

One of the potential pitfalls with poppies is to begin with too dark a red. I usually begin with a pale orange or lemon, adding magenta and more orange to achieve the colour. Note that the really dark tones are the areas of shadow or where a petal crosses. The highlights are left with very thin washes, especially towards the edges of the petals.

WATERCOLOUR FLOWER PORTRAITS

by Wendy Tait

Everyone has their own way of painting and no two ways are the same. There is not a 'right way' if it does not work for you, nor a 'wrong way' if you like the effect. This section is about the way I paint and enjoy painting but I hope it gives you one or two tips on how to make your own style work for you.

I will show you how to paint a misty background and how to pull flowers out of it, deepening around and behind each flower instead of overpainting it. You will also learn how to draw with your brush, rather than with a pencil – this avoids the rubbing out that inevitably follows! There are examples of flowers painted straight on to dry white paper with just a little background added later. Some people find this method relatively easy, but it has many pitfalls, including the fact that you run the risk of ruining the work you have already done. I prefer to begin with a gentle background in the colour range of the flowers I am using, and to then build my painting from there, finishing with the tiny darks that give the all-important contrasts.

I am often asked which are my favourite flowers, but I find it difficult to name them. Each season I look forward to a change of subject as I (almost) always paint from the actual flower.

Good painting depends on good observation, but a successful painting can often depend on what is suggested but not painted in detail. The imagination will supply the eye with the necessary information if led in the right direction. I do not try to paint botanical illustrations, but rather to suggest the feeling of the flowers, the season, even the smell. I really want to appeal to the emotions of the viewer.

The excitement of the clean white paper, the feeling that this is going to be *the* masterpiece – this is what keeps me painting. Usually, I fall into the same traps as most of us do, make the same mistakes and by the time I get halfway through, I realise that the masterpiece is just as far away as ever! However, I am still held by the sheer pleasure of paint, brush, paper and the magic of adventure!

I have included some part-worked paintings which show the stages I go through before deciding that a painting is complete. Deciding this is quite a milestone as it is so easy to take things a little too far and become 'fiddly'. Timing is of the essence at every stage! When I think I have finished a painting, I usually prop it up in my studio for several days, occasionally looking at it to decide whether it is successful and can be mounted and framed, whether it will be consigned to the pile of nearly-made-it-but-not-quites, or whether it is frankly awful. Even if I think a painting is a failure, I still keep it, as it often helps to remind me of areas that did work, even if I subsequently ruined it. Time spent painting is never wasted. Whether a painting is successful or not is often a question of personal choice anyway. The main aim should be to practise, practise, practise.

I hope it is the same for you, and that just one little tip or idea in this section will start you off on your own voyage of discovery.

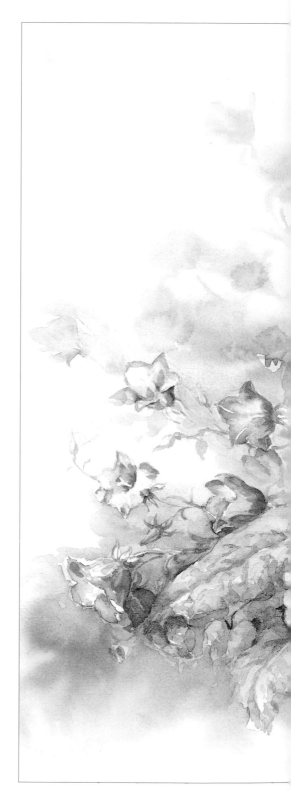

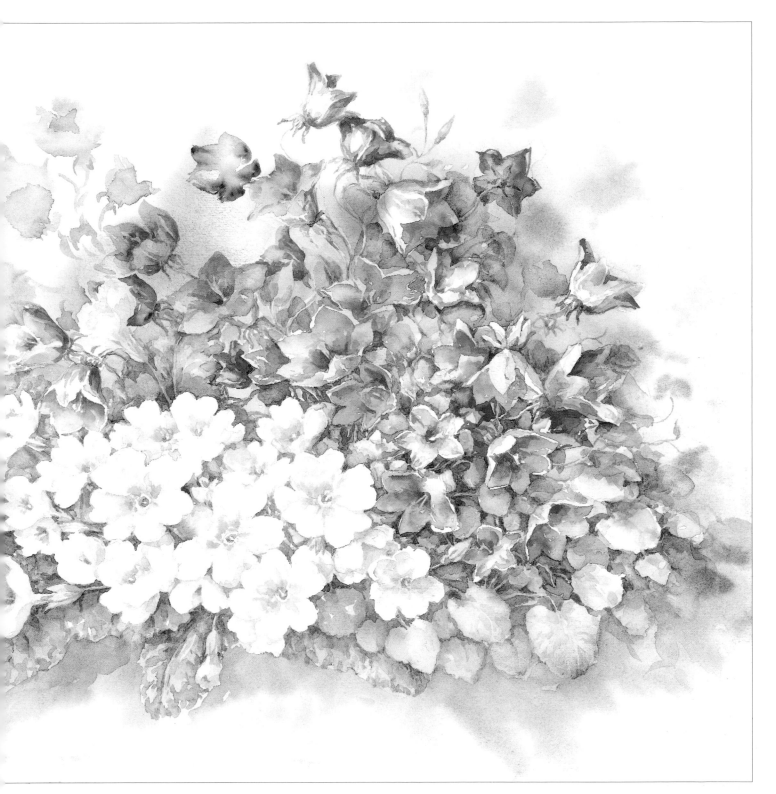

Primroses and Campanulas

These blue and violet campanulas contrast with the pale yellow of the primroses. Note the misty blue background flowers painted on wet paper, that carry the blue tones right through the painting.

Choosing your colours

My palette for flower portraits

Different palettes are needed for different subjects – for example, a flower palette uses a lot of pinks and violets instead of the earth colours you would expect to use for a landscape.

I use a large plastic palette because it is inexpensive, light and easy to clean. I tend to clean out only the mixing areas after finishing a painting, not the wells of colour. When I mix my colours, I always squeeze the colours out in the same order. It makes the selection of colours easier if you know where they are. I like to decant two Winsor lemons (one to keep pure and the other for my basic green mix with Payne's gray) and two cobalt blue deeps (again, one to keep pure, the other to mix from). I find I squeeze out the majority of my colours each time I paint, as I never know when a touch of something I do not often use, will supply just the tone I need.

I never use white, mainly because my first art tutor taught me not to. However, this is a matter of personal preference. Also, I like the paper to shine through pale washes and for this reason, most of my colours are transparent. Winsor orange is the only paint I use regularly that is opaque, and I use this very sparingly.

When you have finished painting for the day, drop your palette into a plastic bag with a paper towel over it to mop up any excess liquid. This will stop paint from spreading on to other materials in your bag.

My palette

The colours below are listed in the order that I place them on my palette.

Cobalt blue deep

Ultramarine violet

Winsor violet

Brown madder

Winsor orange

Quinacridone magenta

Scarlet lake

Permanent rose

Quinacridone gold

Raw umber

Raw sienna

New gamboge

Payne's gray ⎤
⎥ (basic green mix)
Winsor lemon ⎦

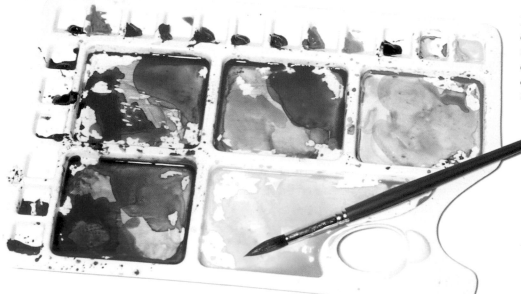

I always place my paints in a set order in my palette so I can locate them easily. I usually have two compartments for Winsor lemon and cobalt blue deep – one of each to keep pure, the other for mixing.

Colour mixing

The mixes on this page are included to give a few very simple ideas that are ideal for flower portraits. Experiment by putting one pool of colour, e.g. Winsor orange, next to another colour, e.g. a pool of quinacridone magenta. Gently overlap the edges of the colour, not the whole puddle; tease it out over the clean area and strengthen it until you have several tones of pink, orange and red. As the colour dries on the palette, these are valuable sources of different tones of the colour. The last examples on the chart below show pale mixes of the colours I would use to shadow very pale or white flowers.

Violet is a must. It has so many uses – particularly in shadows for autumn subjects, but it also makes a wonderful colour for the centre of pansies when added to brown madder. When I refer to violet in this section, it is usually to Winsor violet; ultramarine violet and scarlet lake are in my palette for very occasional use. If you do not have a violet and need to mix one, you will soon discover that any old red and blue do not make violet – they make mud. Use a blue-based red, such as permanent rose or quinacridone magenta, added to cobalt blue deep.

Tip

I never use green straight from the tube as I find it can be very garish. I prefer to mix my own greens from Winsor lemon and Payne's gray, adding cobalt blue deep to cool it, or quinacridone gold or raw sienna to warm it.

When mixing washes, think about the ratio of pigment to water. Remember that as you work through your painting, you will need lots of water to begin the background washes, then progressively less as you move towards more detailed work.

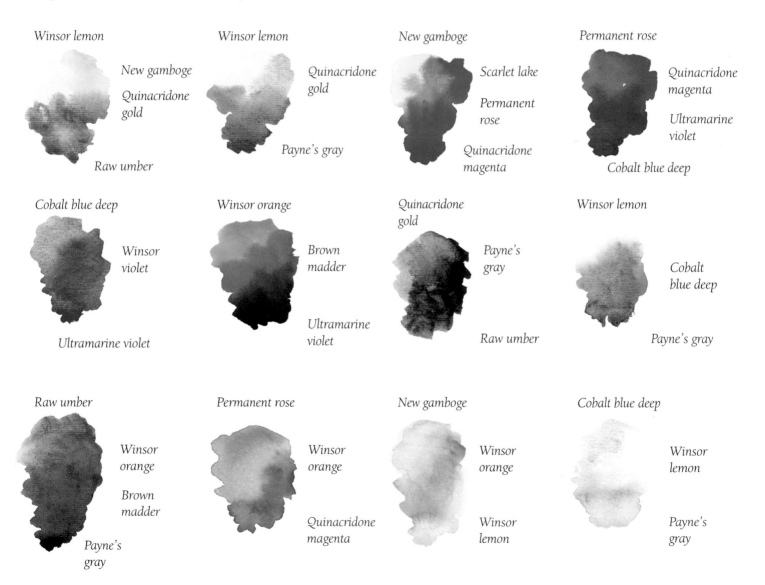

Winsor lemon
New gamboge
Quinacridone gold
Raw umber

Winsor lemon
Quinacridone gold
Payne's gray

New gamboge
Scarlet lake
Permanent rose
Quinacridone magenta

Permanent rose
Quinacridone magenta
Ultramarine violet
Cobalt blue deep

Cobalt blue deep
Winsor violet
Ultramarine violet

Winsor orange
Brown madder
Ultramarine violet

Quinacridone gold
Payne's gray
Raw umber

Winsor lemon
Cobalt blue deep
Payne's gray

Raw umber
Winsor orange
Brown madder
Payne's gray

Permanent rose
Winsor orange
Quinacridone magenta

New gamboge
Winsor orange
Winsor lemon

Cobalt blue deep
Winsor lemon
Payne's gray

Cool colours

If you use cool tones in a painting you can give the feeling of climate rather than direct botanical illustration. Here I have used predominantly pale mixes of lemons, blues and greens.

Daffodils and primroses

Cool colours are used in these pale flowers early in the season. Their freshness is contrasted with a bluey violet mix in the background, with added strength behind the central flowers. The colours I have used here are cobalt blue deep, Winsor lemon, new gamboge, Winsor violet, permanent rose and a basic green mix (see page 59).

Warm colours

A warm painting will have the emphasis on pinks and reds. Your initial palette may be exactly the same as for a cool painting, but you simply change the proportions of mixes to achieve the effect of more warmth. For example, add tiny amounts of orange to pinks, to create more reds.

Sweet peas

Although this painting uses mainly the same colours as the one opposite, I have changed the balance towards warmth by creating more pinks and reds and by adding more violet to the background. The colours used are cobalt blue deep, Winsor violet, quinacridone magenta, permanent rose, Winsor orange and the basic green mix (see page 59).

Tulips

This painting combines both warm and cool colours – pinks, violets and a warm golden background give it a glow, and the light greens are used to balance the effect. If the accent were on the blue-greens, the painting would look much cooler. The colours used are Winsor lemon, raw sienna, Winsor orange, scarlet lake, permanent rose, quinacridone magenta, Winsor violet, cobalt blue deep and brown madder.

Painting terms explained

Although I have illustrated each of the painting terms used in producing flower portraits here, any one of them can actually be applied to each of the examples. All the compositions contain elements of counterchange, negative painting, lost and found edges and aerial perspective. Although these sound like complicated terms, they describe simple things – in fact, you are probably already achieving what is covered here, without thinking about it!

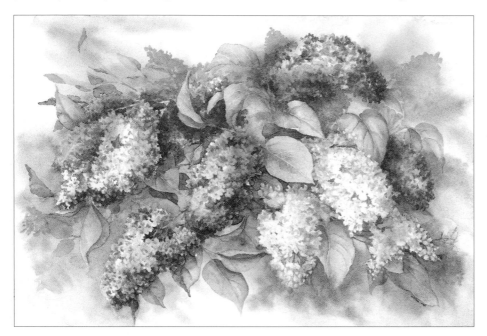

Lost and found edges

This is a term used to describe how soft and sharp lines can both be used to define elements in a painting. The lilac blossom here sometimes emerges with a sharp (found) edge, against a background of leaf or shadow, or it appears to be indistinct, and its edge becomes lost. The bindweed and brambles (pages 90–91) is another good example of this, with its sharp, tangled hedgerow and soft misty leaves.

Counterchange

In simple terms, counterchange means light against dark, dark against light. It is used to emphasise elements of the painting. In this example of cherry blossom, the pale pink blossom has been painted against darker pink blossom and the very dark background is placed behind light areas. Also note the little dark buds against the pale background.

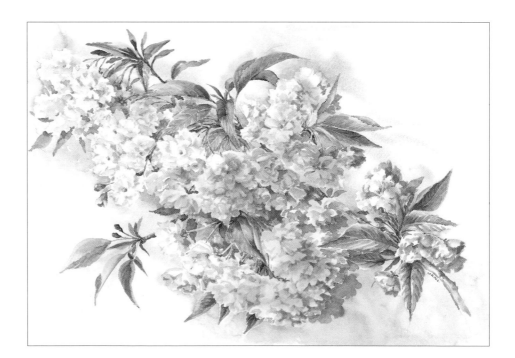

Negative painting

The way to create a delicate flower is to paint the background, not the flower. This is called negative painting and it can be used to great effect. It is a way of suggesting form by painting the negative rather than the positive image that you see. For example, in this loose painting of foxgloves and daisies, you can see how the white daisies are created by the little dark shapes around them – these have been carefully painted to suggest leaves and half-seen flowers. Another example can be seen in the small areas between the stems as they cross each other.

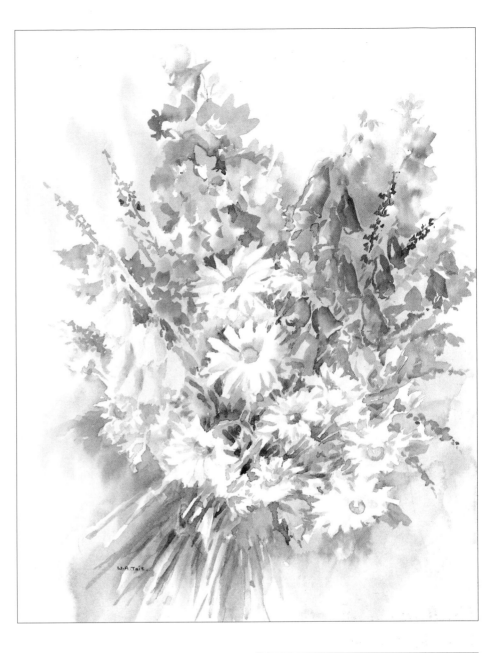

Aerial perspective

Aerial perspective is used in landscapes to show how objects close to you are larger and stronger in colour, tone and detail, than those further away. It is used on a smaller scale with flowers too, to make sure the eye is drawn first of all to the three 'ballerina' roses. Note the detail and warmer tones used on the large roses in the foreground and compare them with the background roses and leaves.

Tip
Successful painting is often about timing. The exact moment to deepen a slightly drying wash (usually when the shine goes off the paper) can only be learned by trial and error. Only many hours of experimentation can teach you this kind of technique!

Composing flower portraits

Once you have decided what you want to paint, set up your subject (or position yourself if you are outside) so that you have a good light source coming clearly from one direction. You will find it easier to paint if you can pinpoint exactly whether the subject is backlit or sidelit. If you can avoid a flat, overhead light, you will help yourself considerably.

Divide your paper into imaginary thirds vertically and horizontally, to create nine sections. Your main flower, or group of flowers (your 'ballerinas' as one of my students describes it) should cross one of these intersections and be just off-centre. It is best to keep them low in the painting. Begin with these and work outwards with softer, smaller flowers, keeping strong tones and contrasts towards the central group.

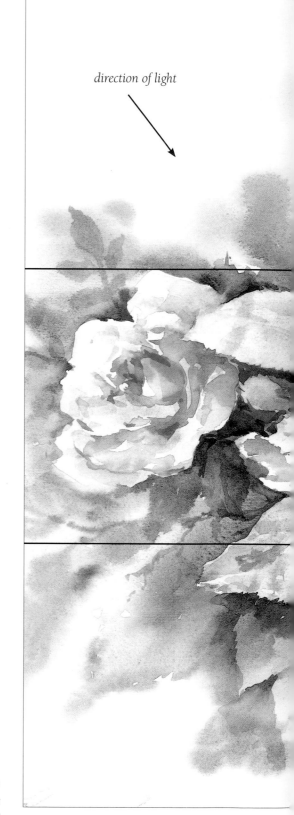

direction of light

Pink Roses
I divide my painting into nine roughly equal sections. The ballerinas, or main flower(s), will be located roughly in the middle section, just off centre, as shown by the circled area.

66

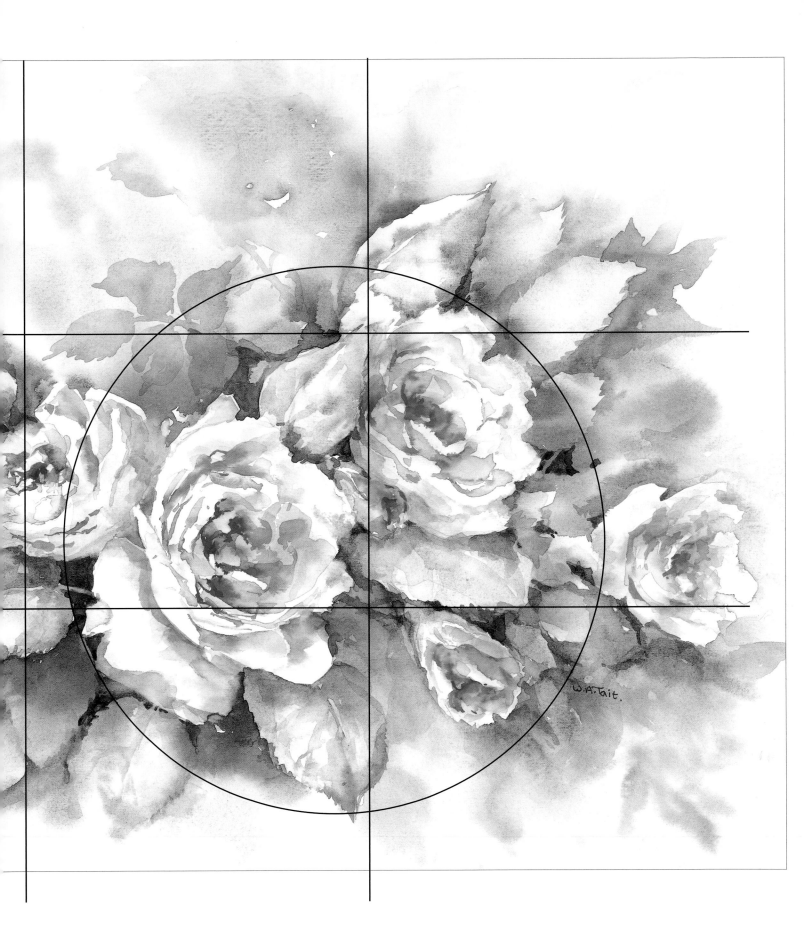

Fuchsias

Fuchsias come with a readymade background of leaves – these can be dropped in using pale tones in the first stage, taking care to leave lots of light areas where the flowers are planned. The tiny dark, negative painting areas (see page 65) should be most intense behind the 'ballerinas'.

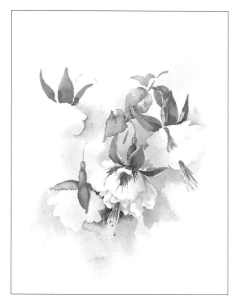

Part-worked fuchsia (1)
This shows some negative painting, i.e. darks behind the flower. I have taken the central flower to its finished state for demonstration purposes. Normally, I would leave these small darks till later in the painting.

Part-worked fuchsia (2)
Note the white flowers painted over a green or blue tint and the use of negative painting around them to show them up. The tinting on the flowers provides the shadow.

Fuchsia
This picture is cooler than the studies above, as the fuchsias were much more lilac and blue in colour. Even the pale pink ones are shadowed in pink mixed with blue. Note the tiny intense darks, which give the effect of throwing the pale flowers forward.

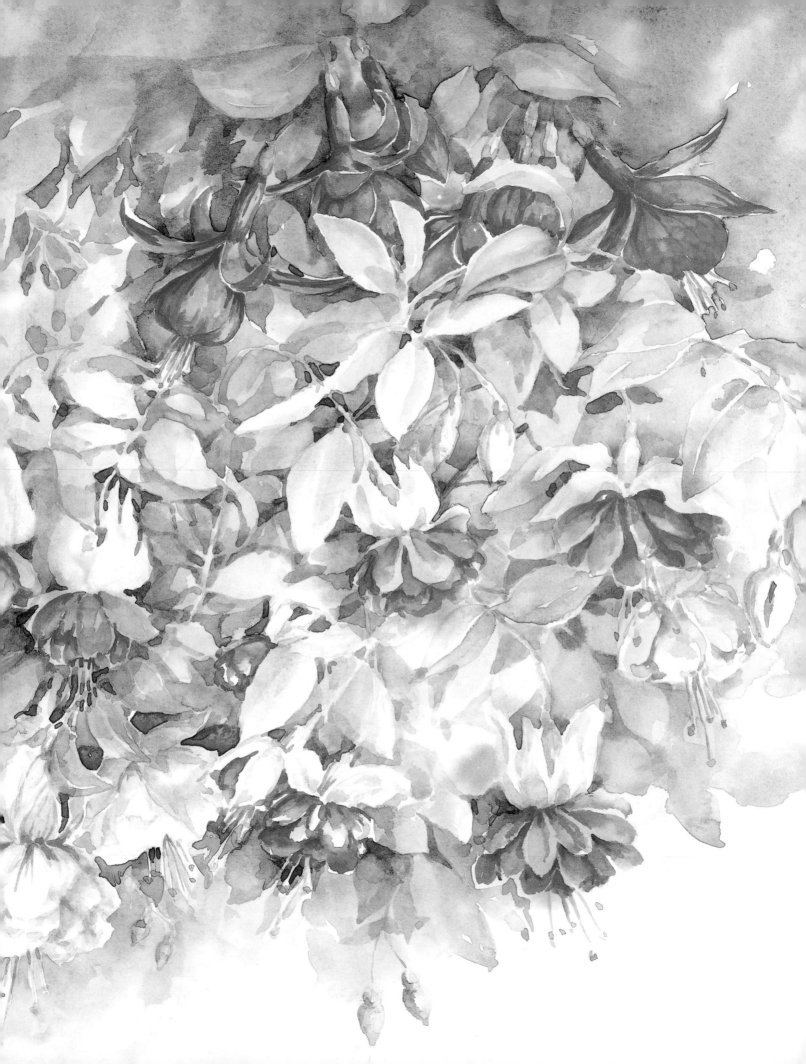

Cyclamen

These delicate flowers have a lovely butterfly shape and care must be taken not to become too heavy with the colours. The leaves deserve attention too, but I frequently shorten the stems of the flowers by looking down on them, instead of viewing them at eye level. This is a good tip for many long-stemmed flowers, as the leaves then create a background leading up to the flowers, instead of leaving an uncomfortable gap.

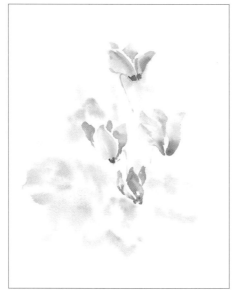

Part-worked cyclamen (1)

Here, I have painted in a very pale background wash using Winsor lemon, cobalt blue deep and a green mix. I drew in the composition of the leaves with loose brushstrokes while the background was slightly damp.

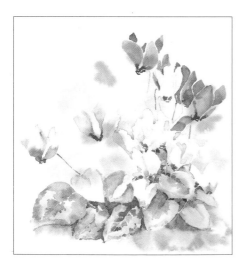

Part-worked cyclamen (2)

These cyclamen are again painted using pale colours – permanent rose and quinacridone magenta. I have left many light areas for the flowers. This study shows the stage of deepening the colours on and around the leaves.

Cyclamen

I decided to make this a cool painting, adding plenty of blue to the background and the shadows on both the flowers and the leaves. My subject was actually three pots of cyclamen placed very close together so that the pale flowers showed up well against the deep pink ones. It is not necessary to detail all the leaves as the imagination will supply any missing information.

Roses

The key to painting roses is to relax – it does not matter if you are on the 'wrong row' of petals – only you will know. I am sure you will find your own way to paint these marvellous flowers, but here are a few tips worth remembering to set you on your way:

• Rose thorns always curve downwards.

• The veins are rarely seen the whole length of the leaf.

• The shine on the leaves of roses (and ivy and holly) is blue in shade.

• When painting a red rose, paint in quite a pale colour to begin with, then paint in the deep tones later.

• When painting a pale rose, remember that a little paint goes a long, long way.

Opposite
Roses and Larkspur

These simple roses were painted very quickly for a demonstration – there was no time to 'fiddle', and so the result is fresh and informal. However, notice that as a result of working so quickly, this is not a good composition; the main flower is much too central and the three roses form a line. This sometimes happens with a demonstration piece, when I do not have time to step back and evaluate. It is all part of the learning process!

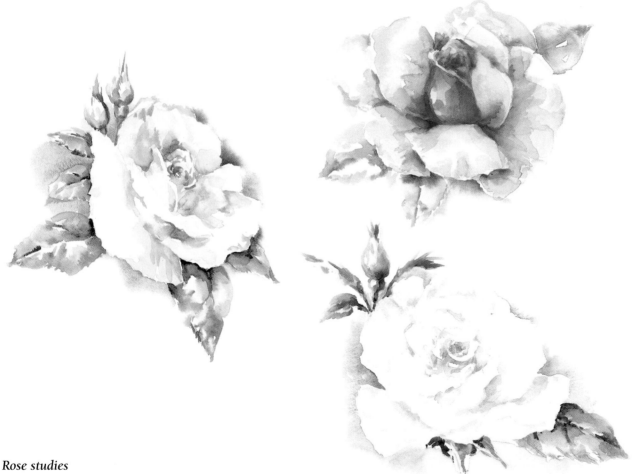

Rose studies

These three roses are painted loosely from photographs – this is a good way of painting roses in the winter! Do not try too hard to make an exact copy of the photograph, but use the time as a practice exercise only, to help you prepare for painting from life later in the year. Note the cool tones on the outer petals of the pink rose, and the warm tones in the centre of the white rose. The centres of all the roses have been painted without too much detail, leaving a little to the imagination.

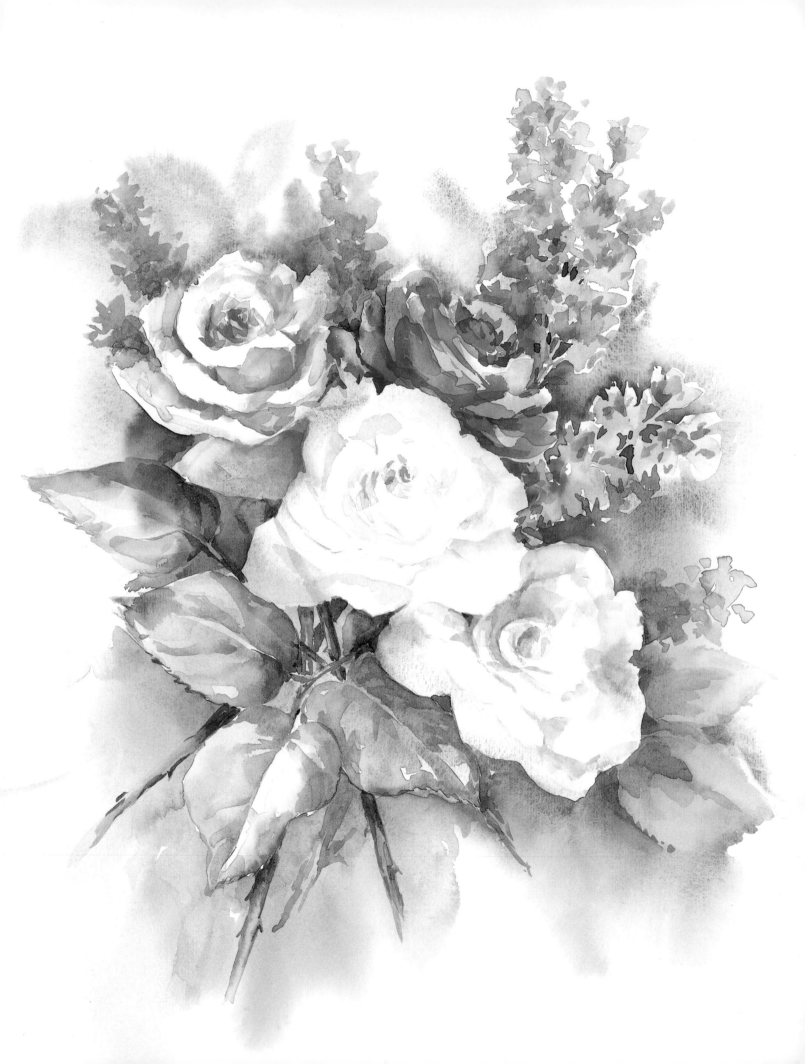

Daffodils and Catkins

This project is a simple one painted straight on to dry white paper, and it includes just a trace of a background. The tones gradually deepen as the painting progresses; each time a deeper tone is used, a smaller area is covered. It is important to keep your tones very pale in the initial stages of the painting so as not to lose the light – you can always darken them later if you feel you need to.

I always prefer to work from real flowers. If they are in a vase, as these daffodils are, you can turn them as you work, to get the angle of each flower that you want. I tend to paint flowers approximately life size, usually on an A3 (16½ x 11¾in) or A4 (11¾ x 8¼in) paper block.

Begin with a piece of paper larger than you think you will need. This allows for 'headroom' as your painting grows.

You will need

Watercolour paper 300gsm (140lb)
Brushes: No. 10 or 12 round, Hake brush
Watercolour paints: Winsor lemon, cobalt blue deep, Winsor orange, new gamboge, Winsor violet, raw sienna, Payne's gray

Before you begin, mix the main washes:

1) Payne's gray and Winsor lemon (basic green)
2) Cobalt blue deep with a touch of violet (blue)
3) Winsor lemon and new gamboge (yellow)
4) Raw sienna with a touch of Winsor violet (brown)

1. Use the yellow mix to paint in the centre of the daffodil then add a little of the basic green mix to the centre. Deepen this green mix with

2. Darken the centre with the blue-green mix. Add more new gamboge to the yellow mix to create a stronger colour, then use this to define the flower centre. Create a few shadows using a little raw sienna.

3. Paint in the trumpet of the second flower with the stronger yellow mix. Paint in two petals with the pale yellow mix.

4. Add details to the petals using a touch of the green mix. Paint in the centre of the trumpet using deeper tones of the yellow with a touch of raw sienna. Add clean water to the paint to dilute the colours towards the trumpet edge.

5. Paint in the third flower using the paler yellow mix and add the green mix to the base. Paint in the more deeply shadowed petals

6. Use a warmer golden tone to paint in the trumpet. Use paler tones to strengthen the outline of the petals. Add raw sienna to the stronger yellow mix and define the crinkles at the edge of the trumpet. Use the same golden tones with a touch of violet to add the caul. Paint in the deep tone on the shadow side, then add water to the colour on the paper to dilute it slightly. Lift off a little colour with your brush to suggest light coming from above.

8. Paint in the catkins using raw sienna and Winsor violet added to the green mix. Leave to dry.

7. Use the basic green mix with a touch of cobalt blue deep, to paint in the stems. Leave areas of white where they are highlighted. Add the leaves, blending and diluting the colour where the leaves turn.

Tip

Work from the outer edge of the petals in towards the centre or more deeply-toned area to avoid hard edges. Sometimes, you may find it helps to turn your paper as you work.

9. Wet the white paper behind the flowers using the round brush, then use the hake brush to wet the large area right to the edge of your paper. Use the round brush to drop in a mix of cobalt blue deep with a touch of violet, making sure the colour runs and deepens behind the flower.

The finished painting
Adding just a little background colour right at the end, pulls out the central daffodil. Note that the trumpet is slightly off-centre so that the stamens give an idea of the shape.

Primroses, Pansies and Heather

Watercolour is a wonderful medium if you allow for 'happy accidents' and let it flow. For this reason, I do not draw with a pencil – I find it much more exciting to never quite know what will happen! Many students find this terrifying, but once they try it, they find it exhilarating too. Drawing with a brush means that you do not ruin the surface of the paper with pencil marks, nor do you have the temptation of always rubbing your work out and starting again. It is not as difficult as it sounds, and painting this way means that a unity develops throughout.

As I begin painting, I may decide not to include everything that is in front of me. I want the freedom to be able to change the composition so that it will grow in a natural way. I often like my main subject to be the palest as it gives me plenty of scope for rich background contrasts. It is a good idea to spend some time deciding which part of the subject appeals to you most. Study the subject first in detail, then with your eyes half closed. This will help you to decide on your tonal values.

Before you start painting, you should have a rough idea of where you want to position the flowers. However, after applying the initial background washes, you may find that you need to readjust the composition, depending on what has happened on the paper. This is easily done by laying in new shapes and tones.

Before you begin, mix large puddles of your background colours – these should be almost the same as your subject colours.

You will need

Watercolour paper 300gsm (140lb)
Brushes: No. 10 or 12 round brush, Hake brush
Watercolour paints: Quinacridone gold, new gamboge, permanent rose, quinacridone magenta, Winsor violet, cobalt blue deep, brown madder, Winsor lemon, Payne's gray

1. Wet your paper thoroughly using a hake brush. Change to a No. 10 or 12 round brush and drop in Winsor yellow, cobalt blue deep, permanent rose and a basic green mix, allowing the colours to mingle slightly. Leave light areas where the flowers will be.

Tip

Dropping in colour means literally that – the brush hardly touches the paper. This will create a soft background, with no brushstrokes.

2. Allow the paint to dry slightly then lightly paint in the heather using Winsor violet mixed with permanent rose. Remember that this will be emerging from behind a light pansy, so do not take the stem too far down. Use a little of the green mix on the base of each flower stem. Deepen the tones behind the flower.

3. Place the primrose centres with a little deep yellow (quinacridone gold added to Winsor lemon to give a warm tone). Lightly sketch in the flowers using pale yellow with a touch of blue and green. Each outline can be used as a shadow for the next flower. Soften shadowed areas with a clean brush.

4. Use a diluted mix of permanent rose to paint in the first pansy petal, then add Winsor violet shadows. Paint in each petal separately, working with diluted pink (permanent rose) on the outside, then adding more colour towards the flower centre. When the petals are dry, add a touch of quinacridone gold in the centre. Leave to dry.

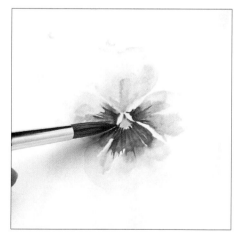

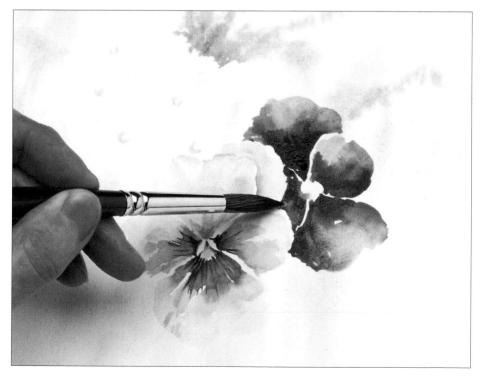

5. Add more gold, then use a mix of brown madder and Winsor violet for the veins. Work from the centre out on each petal – this is one of the few times you do not work from the outside in. Add a touch of darker tone in the flower centre. Paint the shadowed petal using the same pink with a little violet added.

6. Lay in the second pansy using violet and diluted brown madder. While the paint is still wet, add a much stronger mix of this colour towards the centre of the flower.

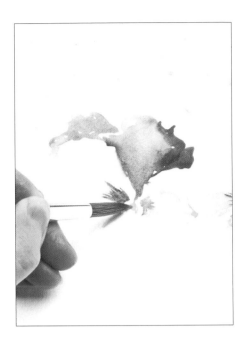

7. Use a very diluted mix of green and cobalt blue deep to paint in the white part of the third pansy. Add quinacridone magenta to the violet and brown madder mix, then paint in the darker petals and flower centre. Paint in the very centre with yellow.

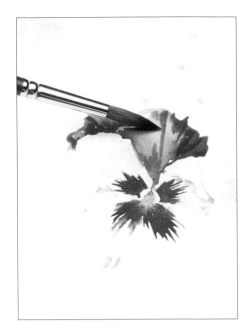

8. Add the veining using a mix of Winsor violet, brown madder and cobalt blue deep. Use light violet to suggest shadow and form. Add a hint of yellowy green where the white petals are in shadow.

9. Define more primroses using a diluted yellow mix. Lightly lay in the stems. Use the green mix to lay in the primrose leaves. While the colours are wet, add deeper tones towards the flowers and around the central veins.

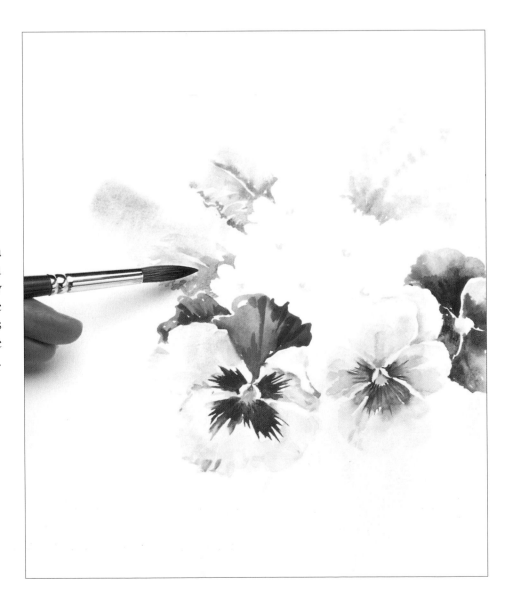

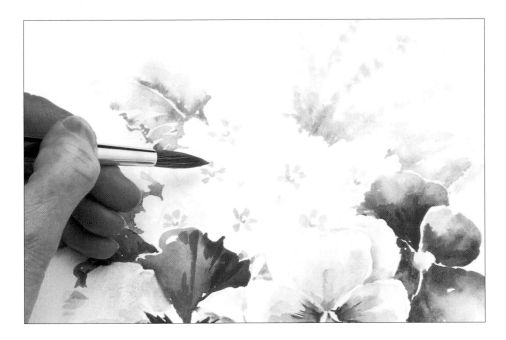

10. Suggest highlighted areas by adding darker tones to some of the primroses. Add detail to selected primrose centres using quinacridone gold. Use a mix of gold and a little green to paint a small horseshoe-shaped shadow into the very centre of each primrose.

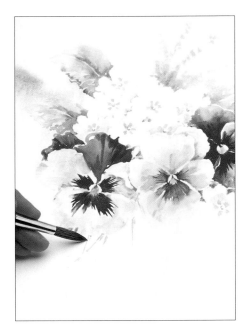

11. Add a yellow centre to the second pansy, then lay in the veining using the deep, rich mix of brown madder, Winsor violet and cobalt blue deep. Introduce more detail into the primrose at the bottom. Where necessary, redefine shapes and correct or soften areas of colour. Paint in another primrose to balance the composition and strengthen the colour of the stems.

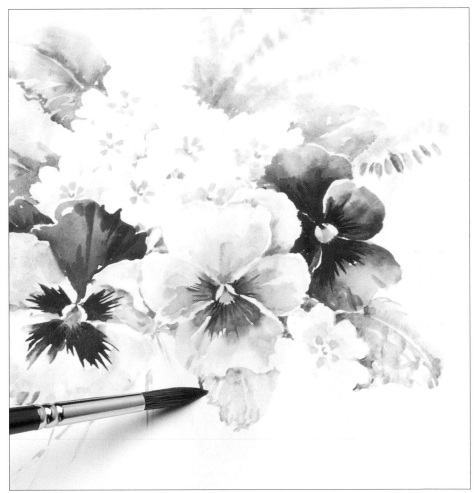

12. Add another leaf in the foreground to define the edge of the pink pansy and to balance the composition. Paint a yellow glaze over the leaves to soften the colours.

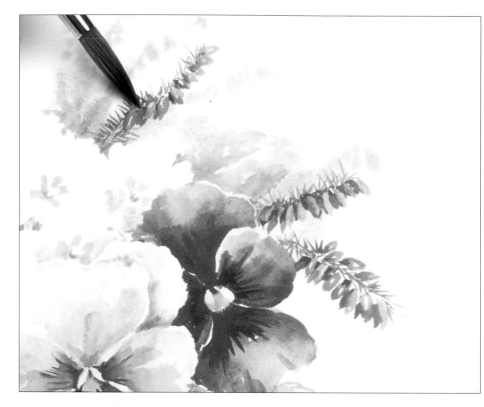

13. Add more detailed heathers using quinacridone magenta. Add shadows with a little Winsor violet. Add green spiky stems using dry brushstrokes to create crisp, clean outlines.

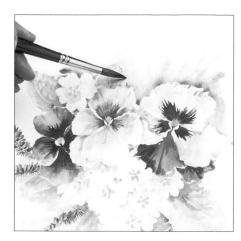

14. Turn the painting upside down. Wet the background using a hake brush. Change to the round brush and run blues, greens, pinks and violets into the wet background. Tilt the paper to ensure that the colours run down towards the flowers, making sure that the flowers themselves are absolutely dry to create a barrier.

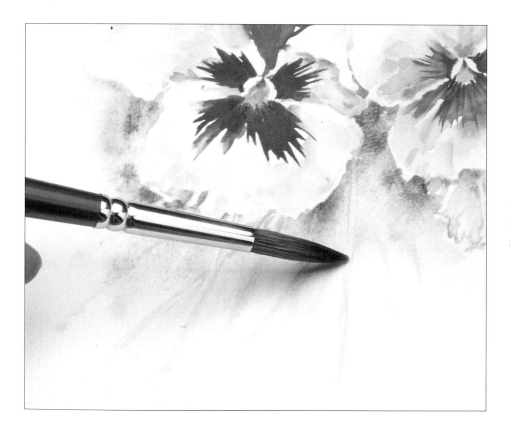

15. Turn the picture the right way up. Deepen the background tones underneath the flowers and leaves and strengthen the stems.

The finished painting
This simple little painting of some of my favourite flowers, illustrates how well pale primroses show up when just a little foliage and background are dropped in behind them.

Anemones

These anemones were a really rich, warm purple, so I decided to keep the background colours to a minimum.

For this painting, my light source was coming from the top right – bear this in mind when working through the project.

Before you begin, study the flowers carefully and then mix up your colours. Start painting with pale or mid tones. Remember that you are trying to paint the light falling on to a deep purple petal, not the true colour you know it to be. If you half close your eyes, you will see that only the shadowed areas are really dark, either close to the central cushions or where one petal crosses another. Try not to outline petals, but use a full brush of dilute colour starting from the outer edge. Allow colour to deepen towards the centre. Remember that every time you use a deeper tone on a petal, you should cover a smaller area than previously, so the final darks are really minimal.

You do not need to reload your brush as frequently as you might think. The same brush-load can often be used to paint several petals quickly, getting paler as the colour is used.

You will need

Watercolour paper 300gsm (140lb)
Brushes: No. 10 or 12 round brush, Hake brush
Watercolour paints: Winsor lemon, new gamboge, Payne's gray, permanent rose, quinacridone magenta, cobalt blue deep, Winsor violet

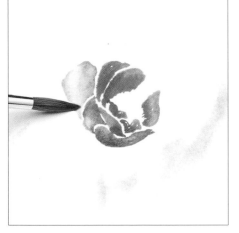

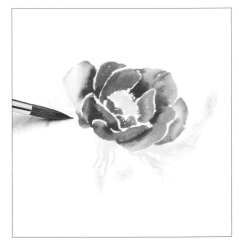

1. Wet the paper with a hake brush. Use a round brush to drop in a little Winsor lemon to give a background glow. Now introduce a little violet and blue mix. Drop in some of the green mix and pull it out to resemble the shapes of the leaves. Remember to leave spaces for the main flowers. Suggest one or two stems as you work out your composition. Leave to dry.

2. Paint in the first petals using a stronger violet mix than used for the background. Leave fine white lines between the petals. These can be filled in later if necessary. Deepen the pigment to work shadowed areas. Add a touch of permanent rose to the violet mix and use this for the outer petals. While the paint is still damp, drop in deeper violet tones at the base of each petal.

3. Use a pale wash of the green mix to paint in the centre. Use the colour left on the brush to pull out a few leaves.

Tip

If an areas dries before you are able to follow the instructions, you can always re-wet it and start again. However, make sure the paper is completely dry before you attempt this.

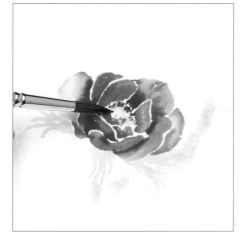

4. While the centre is still damp, go back in with quite a strong mix of Payne's gray and Winsor violet. Deepen the tones of the leaves where they are shadowed by the flower.

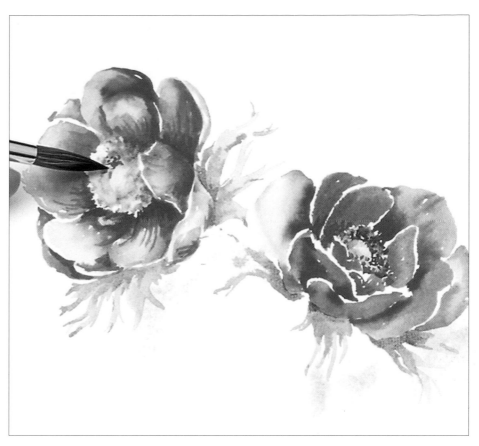

5. Paint in the second flower in the same way and using the same colours as the first one. Add detail to the centre of both flowers using a more intense mix of the Payne's gray and Winsor violet.

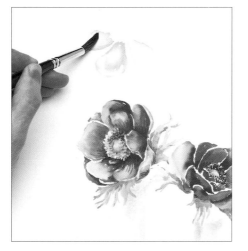

6. Paint in the third, palest flower at the top using a diluted mix of permanent rose and Winsor violet.

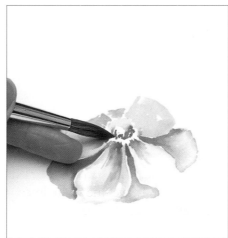

7. Add darker tones to create the shadows and use this same colour for the under layer of petals. Paint the centre of the flower using quinacridone magenta.

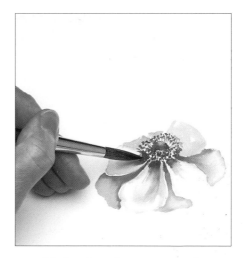

8. Add detail to the centre cushion and paint in the stamens using a strong mix of Payne's gray and violet. Deepen the dark pink shadows even further using quinacridone magenta.

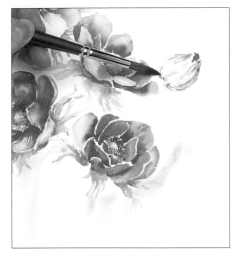

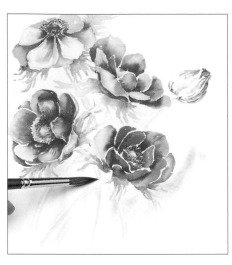

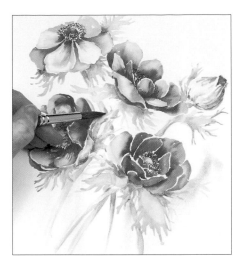

9. Add leaves to the third anemone, then paint in the fourth using the same colours and methods as the first two flowers. Paint the bud pale green and add violet to the shadow side and base to give a velvety look. Remember to leave plenty of light to allow for the shine on the petals.

10. Use the green mix to position the stems.

Tip

Flowers rarely have completely straight stems. Curving them slightly will help your composition and create a more natural-looking painting.

11. Add the centre to the fourth flower. Thicken up some of the leaves, especially the ones around the lower flowers. Add shadows where the stems cross and on the side of the stems away from the light. Introduce a little of the violet flower colour into the stem.

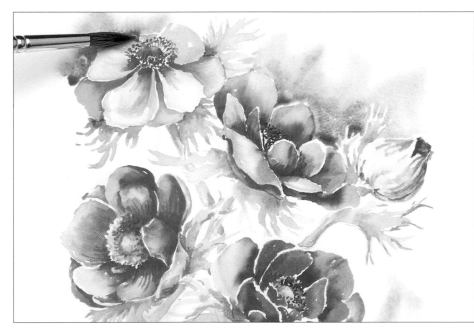

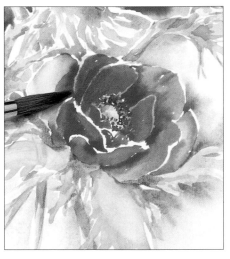

12. Wet the background in sections, then drop in Winsor lemon, the basic green mix, cobalt blue deep and Winsor violet behind the flowers. Tip the paper quickly as you work to move the colour where you want it, so that you have deeper tones behind the flowers. Allow each section to dry before going on to the next.

13. Adjust the tones of the flowers if necessary and deepen areas as required. Wash over some of the white lines between the petals using a very diluted pink mix. This will soften any edges which are a little too hard.

The finished painting
When painting strong-coloured flowers such as anemones, remember
to keep most of the petals pale (you should aim to paint the light falling
upon each one) and only allow deep colour in shadowed areas.

Garden Roses

My basic green mix was used then gold and raw sienna were added to warm the greens and give them the deep tones. Notice how the intense darks only cover very small areas.

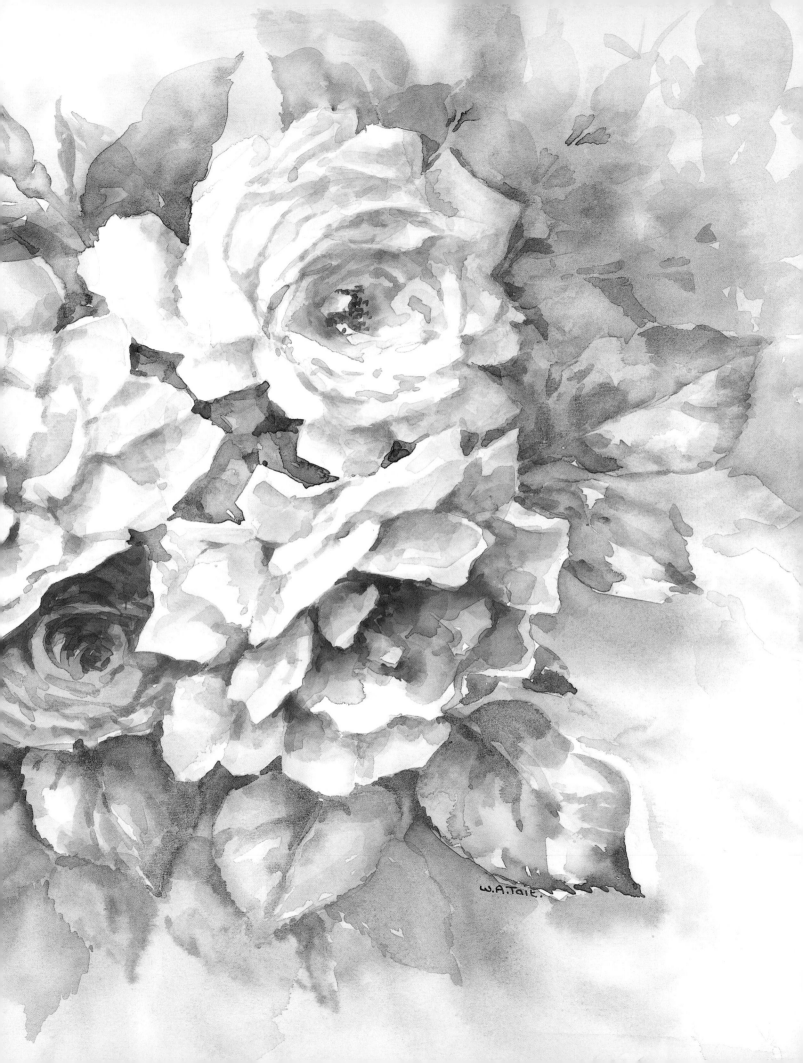

Detail from *Brambles and bindweed*

Although not welcome in my garden, I love to paint bindweed. Painting this tangled hedgerow was quite a challenge, but also deeply satisfying. I think the contrast in this detail between the white flowers and the rich tones of honeysuckle and blackberries works really well.

LIGHT IN FLOWER PAINTING

by Jackie Barrass

Artists over the centuries have employed many different methods to capture light and its transient effects. The reason for this is that light has such a great impact on a painting. Often the most mundane subject matter can be transformed into a beautiful painting simply by capturing the play of light falling on it.

The glowing transparency and spontaneity of watercolour make it an ideal medium with which to interpret some of the qualities of light as they relate to flowers. In addition, watercolour is well-suited to working out of doors. It is lightweight, easily transported, quick and clean to use, and unlike oils it dries almost immediately.

When taking your first steps with watercolour flower painting it is best to work on a small scale and to keep your subjects simple. When you have gained confidence and can manipulate the medium with greater freedom, it is then time to give more consideration to your subject matter. Until then, practise the basic washes as much as you can. Be economical and use both sides of your paper, and even if the results are unsatisfactory do not throw them away.

Beginners often aim to portray all the detail of a flower, but with experience you can learn to simplify a composition into basic shapes that can hold a painting together. You will also soon learn that when working in watercolour you need to think in reverse – from light to dark. It is by using the white of the paper surface that you can produce the cleanest, most sparkling watercolours. You need to determine at the outset where light is to be retained so that you can then preserve this throughout the painting process. This is the most fundamental principle of the medium and once grasped, everything else will start to become easier.

This section will help you think about and, hopefully, explore the exciting opportunities that arise when you study the use of light. My aim is to sharpen your perception and help you to organise your painting skills to produce expressive, individual watercolour paintings. Careful observation and planning are required to succeed – what may appear an effortless painting is usually the result of good forethought and organisation.

The guidance notes I have included are not hard and fast rules – use them as a starting point on your own road to discovery and you will soon 'see the light'. Experimentation is vital to improvement. I know only too well how often an adventurous approach can end in a muddy mess, but the journey will teach you a lot about the medium and its unpredictable habits. Most importantly, relax and have fun!

Opposite
Reach for the Sun
250 x 320mm (9¾ x 12½in)

This quick sketch aims to capture the fleeting beauty of the lily in full bloom using the minimum of brushstrokes and loose washes. The main flower head has been accentuated with darks to provide a focal point.

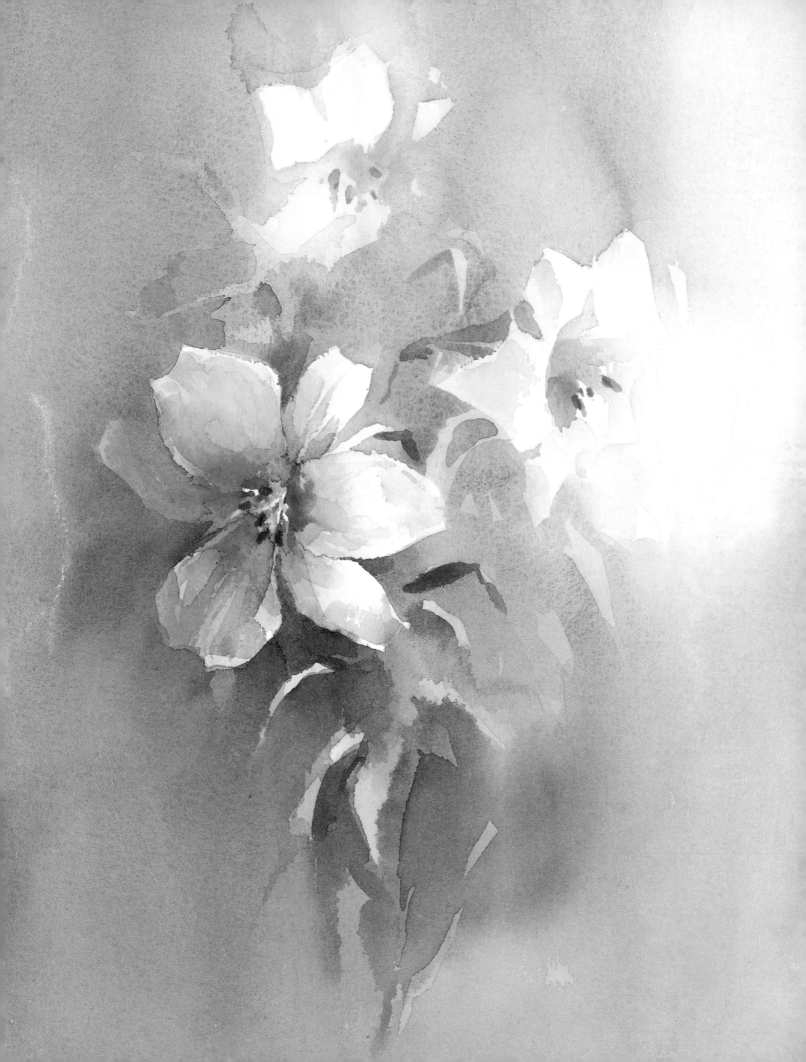

Light and colour

Colour is light. The spectrum shows us that white light contains all colours. An object will reflect some wavelengths and absorb others – the reflected light is the local, or true colour, of that object.

It is not possible to tell if each of us sees colours the same way, so our reaction to them is unique; it may be influenced by memories that trigger an emotional response. With this in mind, it is clear that colour can be a powerful and stimulating tool for self expression.

Some painters prefer to rely on the use of tone in their paintings, and treat colour as secondary to light and shade. Colourists, on the other hand, incorporate colour values and the interaction of colours into every stage of their painting process.

Whichever way you perceive colour in the world around you, one point that needs stressing is that the use of colours and tones must relate to those surrounding them. Therefore, try to maintain momentum over the whole painting surface, and you will achieve a sense of harmony. Do not restrict yourself by working on one area at a time.

You can use a limited palette of just three colours. However, although I use a large range of colours, I limit myself to a maximum of six or seven colours for any one painting. I find this helps create a sense of unity in my finished work.

Decide on your range of colours before you begin a painting. Watercolour is, of course, a fluid and spontaneous medium that does allow you some degree of manipulation as you progress, but you need a clear visual image in your mind at the outset –think about the impression you wish to convey and the colour combinations that will best achieve it.

When trying to analyse colour in your composition, it is useful to remember these characteristics.

Hue *The name of a colour – red, blue, yellow etc. – irrespective of its tone or intensity.*

Tone *The relative lightness or darkness of a colour independent of its hue. Cadmium lemon, for example, is light in tone whilst cadmium yellow is relatively dark.*

Intensity *The brightness of a colour. Some colours, such as cadmium red, are really vibrant and can dominate surrounding colours, whereas light red is an earthy duller red with less intensity. The intensity of colours can be reduced by adding, say, a complementary colour of similar tone.*

Temperature *The closeness of a colour to the warm (red/yellow) or cool (blue/green) parts of the spectrum. However, 'warm' hues can also vary in temperature. Cadmium red is considered as a warm red, while permanent rose is much cooler. Similarly, pthalo blue is relatively cooler in temperature than French ultramarine.*

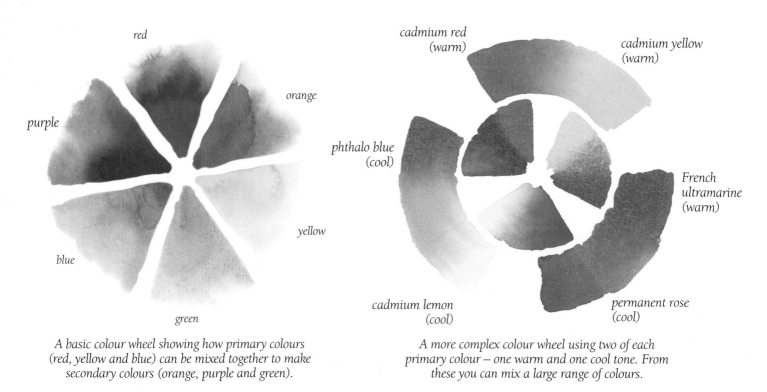

A basic colour wheel showing how primary colours (red, yellow and blue) can be mixed together to make secondary colours (orange, purple and green).

A more complex colour wheel using two of each primary colour – one warm and one cool tone. From these you can mix a large range of colours.

Chrysanthemums and Honesty
235 x 330mm (9¼ x 13in)

*These big shaggy flower heads contrast
sharply with the paper-thin seed pod
linings of the honesty to create an almost
abstract design.*

Backlit Lily

Positive and negative shapes are used to portray this well-lit lily. The paint is applied using a controlled wet-into-wet technique. Let the medium do the work and try not to overpaint the flower head so that it becomes laboured and dull.

You will need

Watercolour paper 300gsm (140lb)
Brushes: No. 8 round, No. 14 round, and No. 1 rigger
Watercolour paints: Aureolin, burnt sienna, cobalt violet, permanent magenta, phthalo blue, Winsor red
2B pencil
Masking fluid and old paintbrush, or the end of a small brush or stick

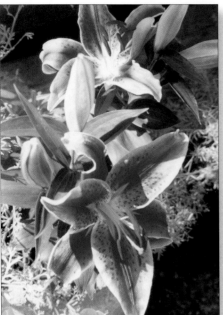

A photograph of the lilies that I based my painting on.

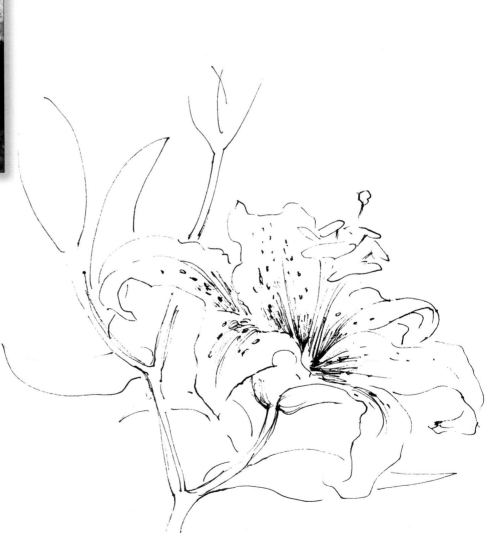

I drew this sketch from life, then used it as the composition for this demonstration.

1. Sketch in the main elements of the painting. Use the end of a paintbrush to apply masking fluid to the stamens and pistils.

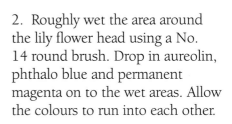

2. Roughly wet the area around the lily flower head using a No. 14 round brush. Drop in aureolin, phthalo blue and permanent magenta on to the wet areas. Allow the colours to run into each other.

3. While still wet, use a No. 8 round brush and the same colours as in the previous step to further define the edges of the petals. Leave to dry.

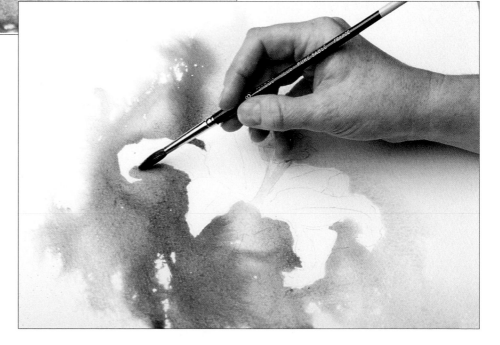

4. Remove some of the pencil marks around the edges of the petals then dampen the middle of the petals, leaving the very outer edges dry. Use a No. 8 round brush to drag in almost undiluted permanent magenta in the centre of each petal. This will soften off over the pre-dampened paper.

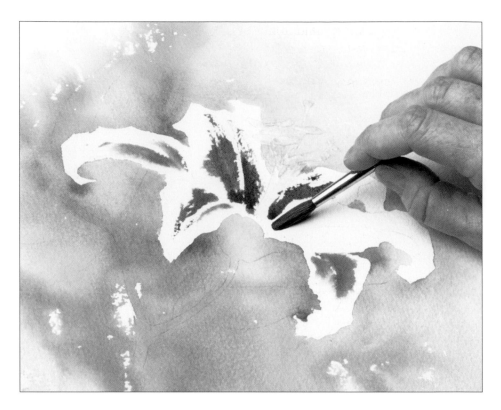

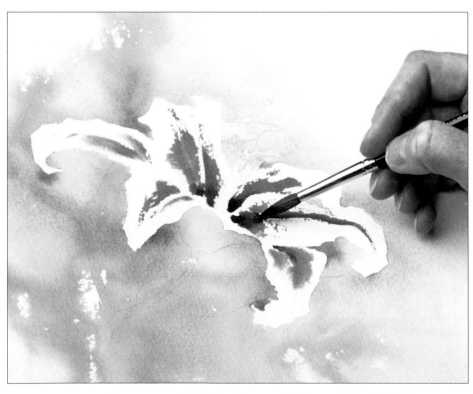

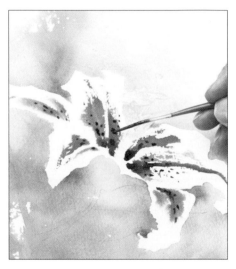

6. Use a No. 1 rigger and permanent magenta mixed with a touch of Winsor red to add spots around the base of the petals. Leave to dry.

5. Drop in a small amount of phthalo blue at the base of some of the petals to give impact.

7. Remove the masking fluid from the stamens and pistils, then paint the base of the stamens using aureolin and a No. 8 round brush. Leave to dry.

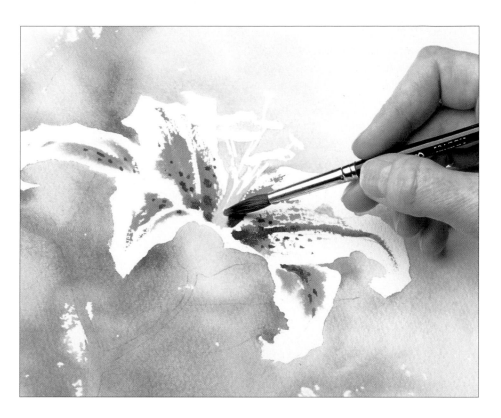

8. Paint in the pistils using burnt sienna and a No. 1 rigger brush. Leave to dry.

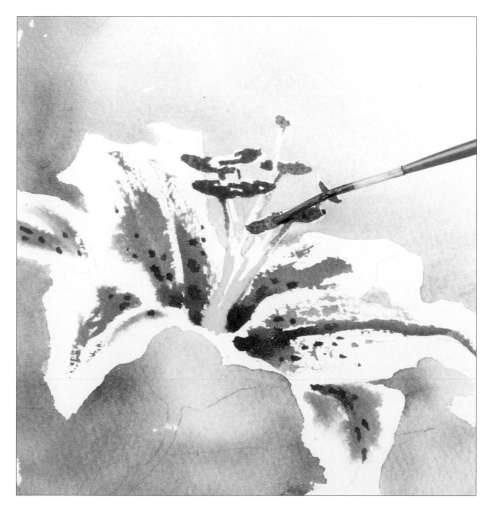

9. Use a No. 8 round brush and a mix of phthalo blue and burnt sienna to lightly define the stems, buds and leaves.

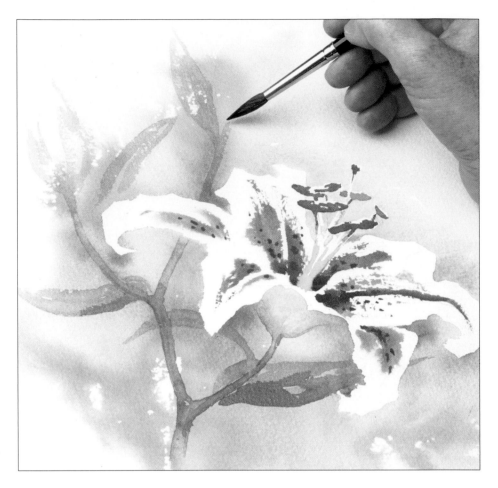

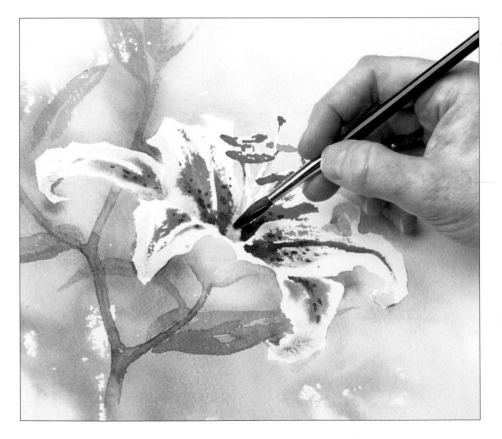

10. Use cobalt violet followed by phthalo blue to introduce shadow to the petals.

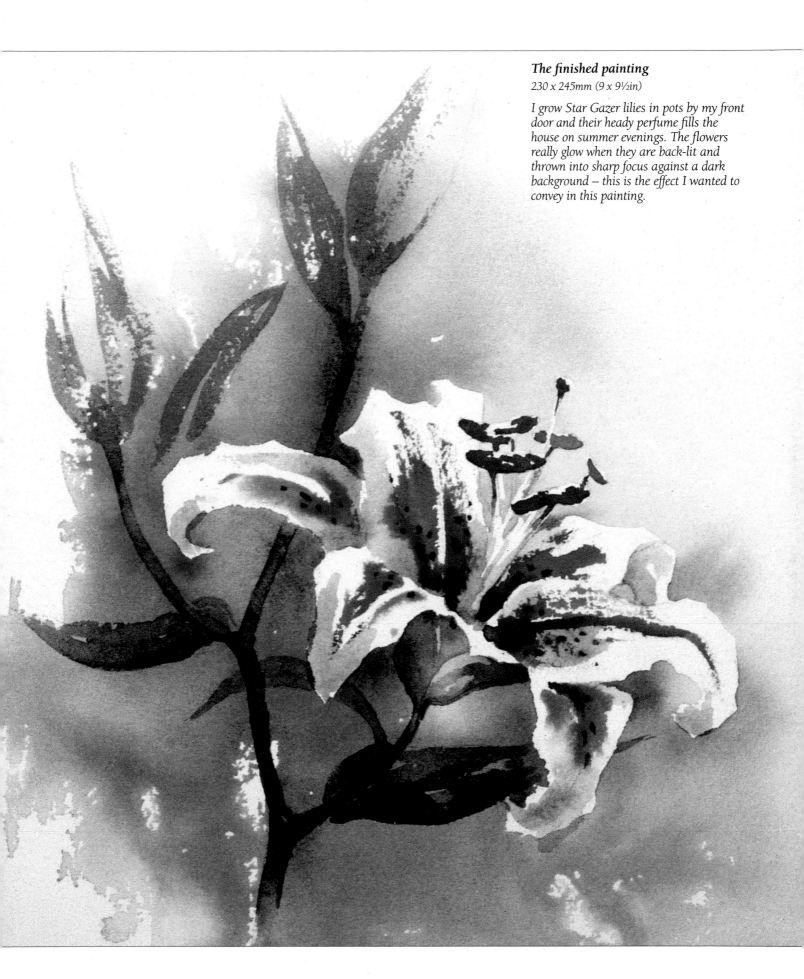

The finished painting
230 x 245mm (9 x 9½in)

I grow Star Gazer lilies in pots by my front door and their heady perfume fills the house on summer evenings. The flowers really glow when they are back-lit and thrown into sharp focus against a dark background – this is the effect I wanted to convey in this painting.

CREATIVE TECHNIQUES FOR FLOWERS

by Richard Bolton

There is a long tradition associated with watercolour painting. Very early paintings tended to be drawings, with pale washes applied to create tone and form. Later, in the eighteenth and nineteenth centuries, when it became fashionable to go on the 'Grand Tour' of classical cities – Rome, Venice and Naples – watercolour artists were taken along to capture scenes on paper, rather as we take a camera on holiday. The artist would often give lessons to his host, and painting with watercolours became popular across a broad spectrum of society. With this popularity, and the ever-increasing prosperity of the Victorian era, came a demand for paintings to grace the walls of the successful industrialists. It was a good time to be a painter, and the skills of the watercolourist developed enormously. Styles varied greatly, and some painters used the medium with such vibrancy that they challenged oil paintings for strength.

When you first start painting, it always helps to look at the work of established artists for inspiration and to give you direction. Some painters are *pure* watercolourists – nothing must be introduced to adulterate their colours – others, like myself, will use other techniques if they help the painting. My style has been developed over many years. When I first started painting, I followed the 'rules' and created loose transparent images. However, I soon found that I wanted to take my paintings further, so I have gradually introduced different techniques to add texture and complexity to my pictures.

Problems multiply with size, and it takes time to understand the limitations of watercolours. Every brushstroke counts and demands your full attention so, when you introduce a new technique to your skills, practise on small paintings. Do not give up on a painting too soon – things are bound to go wrong – but try to learn from your mistakes. If you feel that a painting has become dull and overworked or it just looks a mess, instead of throwing it away, take a sponge, wash as much paint off as possible and let it dry out. You will will be left with a very pale version of your original painting that you can paint over and then, perhaps, create a masterpiece.

In this chapter I show some of the techniques I use in my flower paintings, and I hope they will prove exciting and challenging. Do not over use them in your paintings; there is a fine balance to achieve, especially when one wishes to retain the fluid characteristic of the medium. Be a harsh critic of your own work, always look for improvement and, gradually, your skills and confidence will grow.

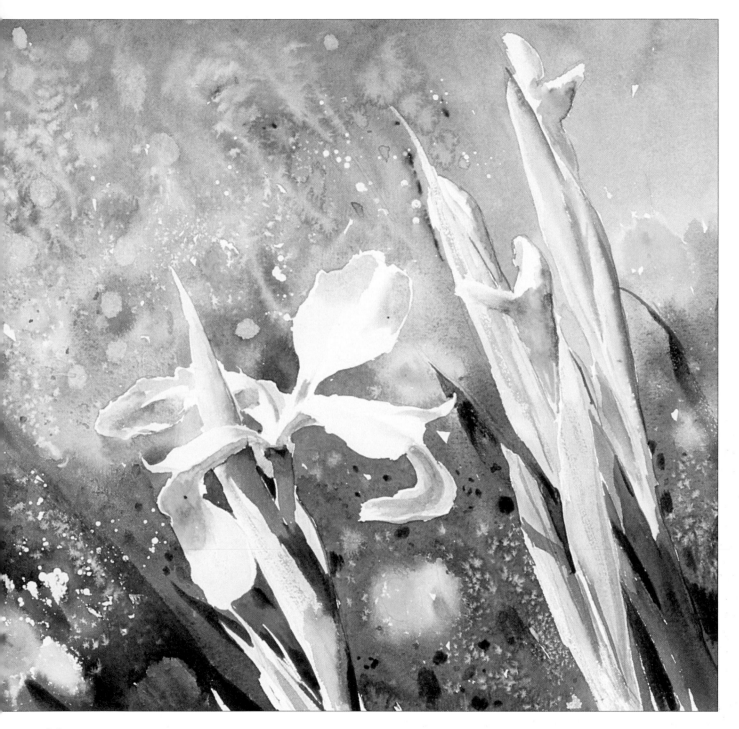

Irises

340 x 325mm (13½ x 12½in)

I used masking fluid to mask out the foreground detail while I worked on the background. I wetted the paper with clear water, then applied very fluid mixes of cerulean blue and Prussian blue. I dropped gamboge, wet-into-wet, on to the surface and allowed this to spread out into the blues. A brush charged with ox gall (a surfactant medium that lowers the surface tension of the water and thus helps the paint to flow more smoothly) was dragged over the surface and salt scattered into the wet paint to add interest and textures.

The white of the flower petals works well against the darker background and only a little shading of ultramarine, with a touch of burnt sienna, was needed to complete the picture.

Irises

Flower studies provide the opportunity to experiment. I like to focus on one or two flower heads, and depict them in detail against a soft, contrasting background. I chose irises for this first demonstration because they are a particular favourite of mine. They are very sculptural, and the strong, bold outlines of their petals and foliage work very well against a soft, seemingly out-of-focus background.

Before starting to work on the background, I apply masking fluid to all the foreground detail. This allows me to work loosely and quickly over the whole area of the paper. I use the wet-into-wet technique to work splashes of colour into the background, allowing the colours to blend together on the paper. I then add salt to the wet colours to create other interesting effects.

The most important factor about flowers is their freshness, so do not overwork the colours or techniques.

You will need

Not surface watercolour paper 190gsm (90lb)
Brushes: No. 6 round and No. 14 round
Watercolour paints: Cerulean blue, Prussian blue, alizarin crimson, gamboge, cadmium orange, viridian, ultramarine, burnt sienna, dioxazine violet
2B pencil
Masking fluid and an old brush
Table salt
Razor blade and an eraser

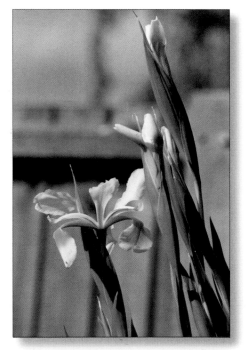

You can paint from photographs of blooms that will not be around for long, but it can be very pleasant sitting in the garden working from life.

1. Use masking fluid and an old brush to outline all the flower petals, stems and leaves. Flick spots of masking fluid randomly over the background area.

2. Use a No. 14 round brush and clear water to wet parts of the background area.

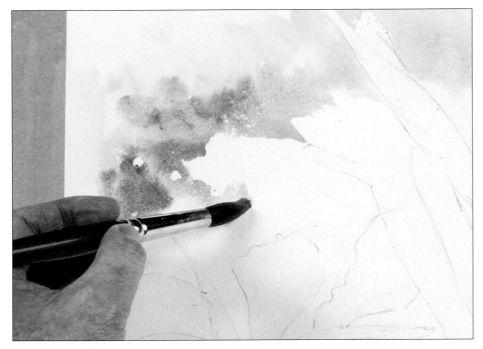

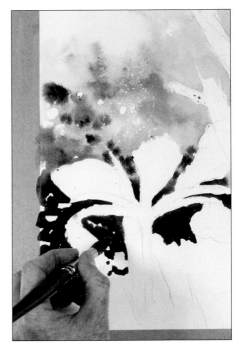

3. Mix a wash of cerulean blue, then paint this randomly across the top part of the background.

4. Mix a wash of Prussian blue with a touch of alizarin crimson, then paint this across the middle parts of the background.

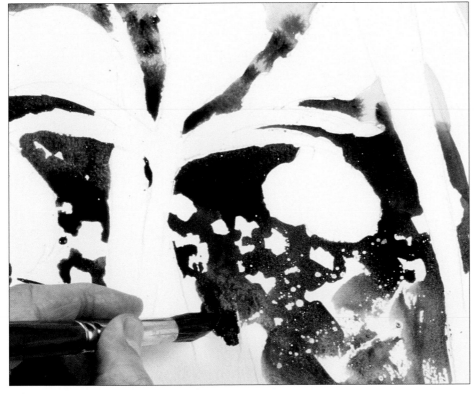

5. Add more alizarin crimson to the wash as you near the bottom of the painting.

6. Dilute the wash, then use a No. 6 round brush to lay in a spike of foliage, wet-into-wet. Splatter spots of cadmium orange, wet-into-wet, randomly over the background.

Salt will continue to work while the paint is wet. You can stop the effect at any time by drying it with a hairdryer.

7. Sprinkle salt randomly over the wet paint. The effect starts almost immediately and will continue to develop all the while the paint is wet.

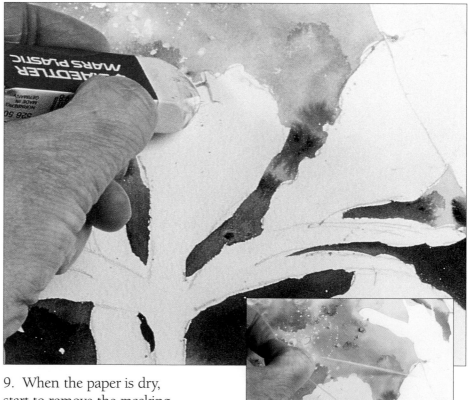

8. When you are happy with the salt effect, dry the painting with a hairdryer – watch out for unwanted hard edges forming.

9. When the paper is dry, start to remove the masking fluid with a soft eraser...

...then pull off the larger pieces with your finger.

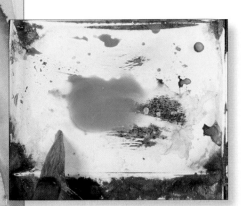

My wash of gamboge, ultramarine and viridian still shows traces of the individual colours.

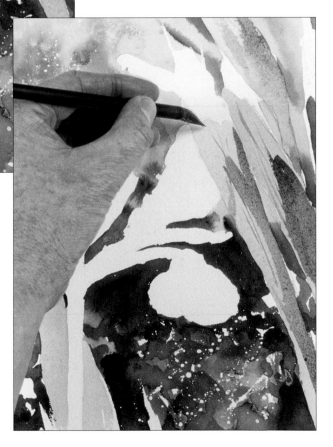

10. Mix a wash of gamboge and a touch of ultramarine, then paint in the leaves and stems. Add a spot of viridian to the wash as you work down the leaves.

11. Add more ultramarine to the wash and start to develop the tone and shape of the foliage. Use the tip of the brush to define the edges of the foliage. At this stage, take care not to overwork the picture, much of its charm relies on the speed and handling of the paint.

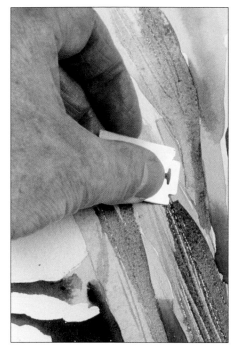

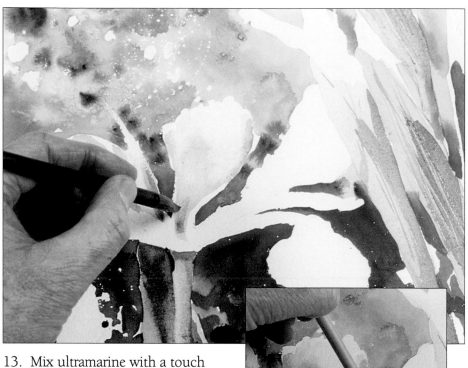

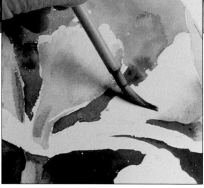

12. Leave the paint to dry slightly, then use the end of a razor blade to scratch fine lines into the dark colours and reveal the paler tones beneath.

13. Mix ultramarine with a touch of burnt sienna and tiny spots of gamboge. Paint the shadowed areas of the white petals, then soften some edges with clear water to make them merge into the white of the paper.

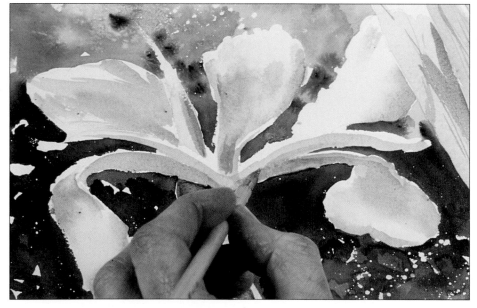

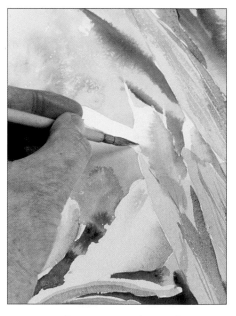

14. Use gamboge and a small round brush to start building up colour on the petals. Soften each area with clear water. Add some shadows using a wash of ultramarine and viridian.

15. Mix dioxazine violet with touches of ultramarine and gamboge, then add tone and shape to the hues.

The finished painting
230 x 340mm (9 x 13½in)

FLOWERS IN THE LANDSCAPE

by Ann Mortimer

Flowers grow everywhere if given a chance. Giant hollyhocks emerge from the smallest crack between city paving slabs, while massed bluebells cover huge swathes of woodland floor in misty carpets of blue. Everywhere you look, there are flowers: window boxes full of bright red geraniums, market stalls brimming with carnations and chrysanthemums, embankments sparkling with ox-eye daisies, seaside cliffs speckled with hardy thrift, pavements outside grocers' shops littered with punnets of pansies, not to mention town parks with their proud displays and front garden paths edged with multicoloured annuals.

Flowers are indeed hard to ignore. They brighten our surroundings, and I can think of no better medium to use to paint flowers in the landscape than watercolour because it is such a lively and dynamic medium. Learning to control it – or should I say to not control it too much – is a challenge. It is, however, all the more fun for being so. Watercolour reveals its secrets gradually to anyone who is prepared to give it a go. As a medium it can be surprising or exasperating, but it is always fascinating and ultimately rewarding.

My hope is that this section will have something for everyone, inspiring you to look for more opportunities for painting flowers in the landscape, and that the tips and techniques will help you to enjoy all your future watercolour adventures.

April Hellebores
33 x 25cm (13 x 10in)

These hellebores were growing in front of a hedge in my garden. Chinks of light were visible through the hedge. I masked these out as well as the main flowers.

I used aureolin, green mixes, alizarin crimson and burnt sienna in a loose first wash, and was careful to leave areas of yellow shining through in the finished picture. The speckles in the flowers are alizarin crimson.

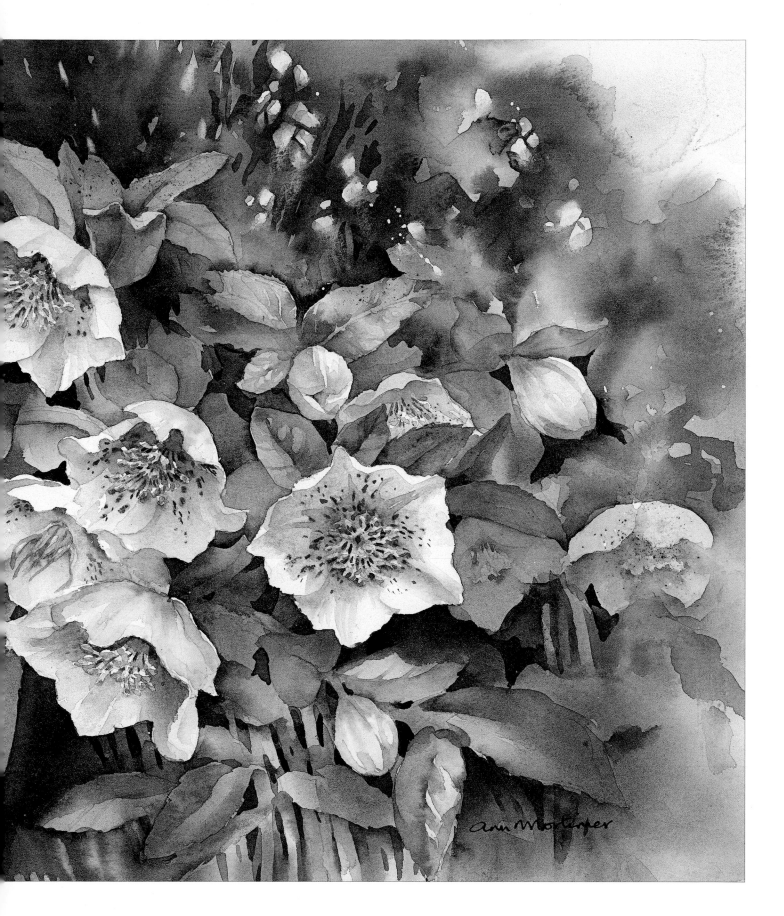

Using colour
My palette

These are the colours I use regularly for flowers in the landscape. The nine colours I have marked with an additional smaller swatch would make a good starting palette for a beginner. They include a mixture of warm and cool yellows, reds, blues and one green.

Aureolin yellow

I often use this clean, bright yellow in my initial washes. To me it represents sunshine on leaves and in the background. It can also be used as a glaze to brighten colours underneath.

Raw sienna

A major player in my palette. I combine this with aureolin to make a more interesting yellow, or with blues and pinks for stonework. It is also a good base colour for tree trunks.

Transparent yellow

This is a useful translucent colour for yellow flowers such as daffodils.

Indian yellow

This yellow can be combined with alizarin crimson to make warm red and orange mixes for the shadow areas of yellow flowers.

Quinacridone gold

This is a useful colour to mix with blues to create natural greens.

Burnt sienna

This is a versatile colour. Combined with blues it makes great darks, and it also make greens look more natural.

Alizarin crimson

This is a cool red which is a useful basic colour to have in the palette. I drop it into raw sienna, wet-into-wet, for stalks and use it with gold to create autumnal shades.

Perylene maroon

I use this robust colour combined with blues and greens to make vibrant darks.

Permanent rose

This is a must for flower painters to use in delicate first washes and to mix with blue for shadows.

Quinacridone magenta

This is a clean, strong pink indispensable for flower painters.

Winsor violet

I like to mix this with blues and pinks for translucent darks.

Winsor blue

A cool blue which works well with Winsor violet for bluebells. When mixed with yellows, it is also a good base for clean greens.

Cobalt blue

This with a touch of permanent rose makes a good shadow colour for white flowers. It is also a mainstay for skies: on its own or with a touch of pink or violet.

French ultramarine

One of my main uses for this is combined with burnt sienna for darks in trees, twigs and stone walls.

Phthalo turquoise

I use this mixed with reds and golds for making clean non-muddy darks.

Viridian

This can be combined with burnt sienna for natural greens or with pink for beautiful greys.

Hooker's green dark

A useful clean bright green which can be combined with yellows or reds for more natural greens.

Sap green

I use this combined with yellow as a quick solution for grasses and young leaves.

113

Colour mixing

There are many bright colours available nowadays. However, in my experience, students often protest that they find it difficult to achieve successful colour mixes.

I often think that it is the way colours are mixed that is at fault rather than the choice of colours. Perhaps we should call the action mingling or combining rather than mixing. It is all too easy to create a muddy grey-brown by mixing colour too energetically. I advise treating the colours with a bit more respect!

Try laying the colours side by side in the palette and then gently combining them in the middle. Do not over-mix the paints as this will make them muddy. Three or more colours should be visible at the same time in the palette. While working on a painting, the palette should ideally look like a version of the finished painting with a range of fresh colour combinations ready for use.

Here is my palette with colours ready, some mingled, some laid side by side giving many different combinations for my brush to dip into.

These illustrations of three colours loosely combined show how many different shades you can produce if you do not over-mix.

Raw sienna, permanent rose and French ultramarine
This gives several possibilities for colours within stonework.

Aureolin, transparent yellow and raw sienna
This gives a nice range of shades for clean, bright looking daffodils.

Hooker's green dark, Winsor blue and burnt sienna
In this combination there are several clean foliage colours for winter greens.

Phthalo turquoise, perylene maroon and quinacridone gold
Here we have clean non-muddy darks, ideal for backgrounds and shaded areas among massed leaves.

French ultramarine, burnt sienna and raw sienna
These three colours, in various ratios, will render tree trunks and twigs.

Winsor blue, Winsor violet and permanent rose
This gives a range of possibilities for bluebells and for flower backgrounds.

Hooker's green dark, burnt sienna and aureolin
Look carefully at this to find many different shades of green.

Cobalt blue, permanent rose and a touch of aureolin
This is a good combination for delicate translucent shadows on white flowers and within cloud formations.

Incorporating the landscape

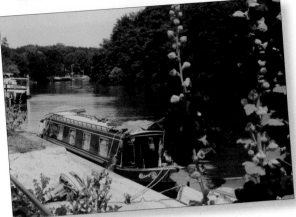

Drawing and scaling up

Some compositions can be quite challenging to get right at the initial drawing stage. A good example is this scene of hollyhocks growing near the River Seine. There is a huge difference in scale between the flowers in the foreground and the barge and river in the background, and this gives plenty of scope for confusion.

With such a composition, I usually use a grid to make a preliminary sketch to get to know the layout. I drew a grid about the same size as the photograph on cartridge paper and overlaid the same size grid on the photograph using a piece of plastic film.

My initial drawing was more or less a contour sketch, feeling my way around the scene as I drew, relating each shape to another while using the grid for guidance.

The original photograph.

The initial sketch, showing the grid. This acts as a check on our assumptions about scale: the eye wants to have each thing the same size, but as you can see, the hollyhocks take up nearly half the space!

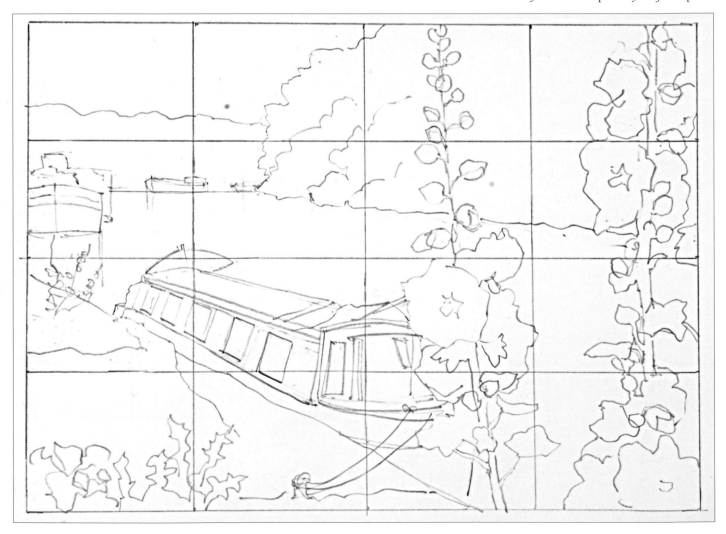

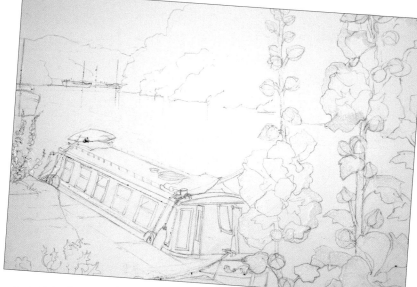

After making the initial study, I scaled it up on to watercolour paper, adding more detail. Here is the sketch, showing masking fluid applied, ready for painting.

Riverside Hollyhocks

37 x 27cm (14½ x 10½in)

During this particular summer in France, there seemed to be hollyhocks everywhere. I like the surprising juxtaposition of the flowers and the river. The rich red hollyhocks stand out against the complementary blue-green of the background.

To render the water, I first laid a wash in the same colours as the sky over it, then added thick vertical strokes of yellows and greens wet-into-wet. As the paint dried, the colours blended and merged on the paper.

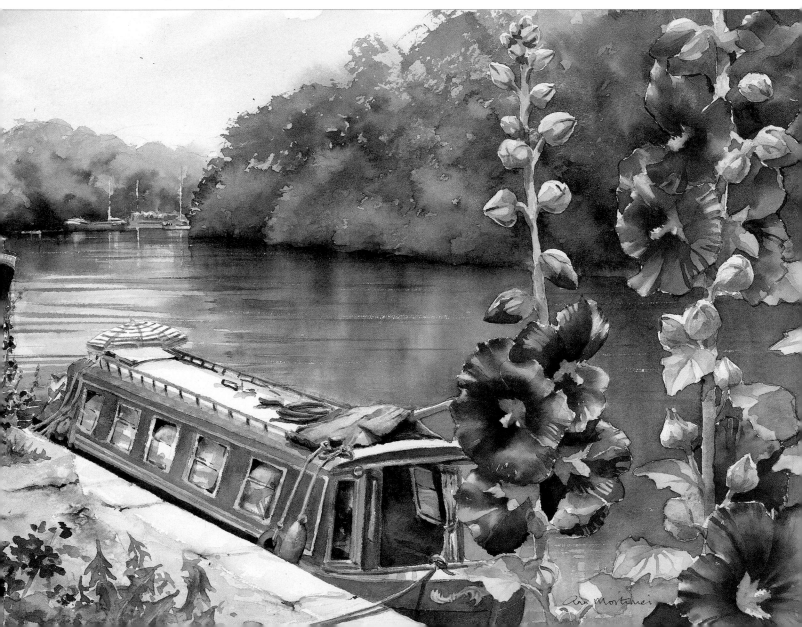

Perspective

Whatever the subject we are painting, perspective will always play a part, often without us realising it. Perspective is just as important in a painting of a vase of flowers as in one of a country road disappearing into the distance. This is because perspective deals in depth.

A sense of depth and of being drawn into a painting will always make it more pleasing and convincing. There are tricks and techniques we can employ to achieve this depth.

For our purposes here, we need to look at perspective in two main areas. These are **linear perspective**, for painting walls and buildings, and **aerial perspective**, for painting trees and flowers in the distance.

You can draw or paint a scene without knowing the rules of perspective if you observe carefully. But having an idea of the rules can give you confidence and will provide a useful means by which to check the accuracy of your work.

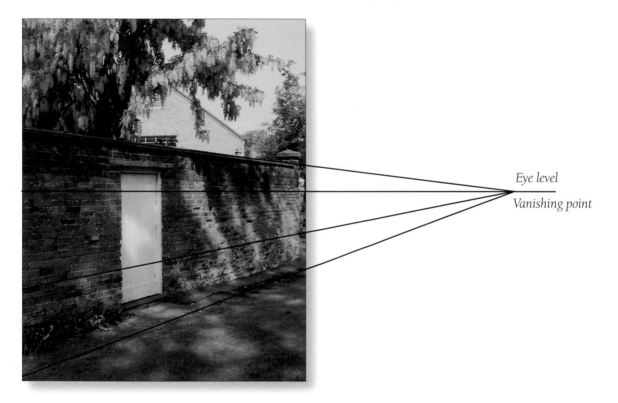

Eye level

Vanishing point

Linear perspective – walls and buildings

When we are out and about, the things that catch our eye as likely painting subjects often include buildings and walls at an angle. These features can act to lead the eye to the focal point of your picture.

In order to draw the wall and door above, the first step is to establish the **eye level**. You can do this by aligning a ruler with the bottom edge of the photo and then moving it up, stopping when you reach a horizontal line of mortar. When working on site, you can find the eye level by placing your hand flat and level with your eyes while looking at the scene in front of you.

Draw a soft line on your paper to mark this eye level. All horizontal features above this level – the door frame, the top of the wall, the lines of mortar – will slope down to this line and all the ones below it will slope up to it. If you draw lines through these features to the eye level (as shown above), they will all meet at the same place. This is called the **vanishing point**.

Once you have found the vanishing point, you can make sure that all the horizontal lines converge here and your wall or building will look correct.

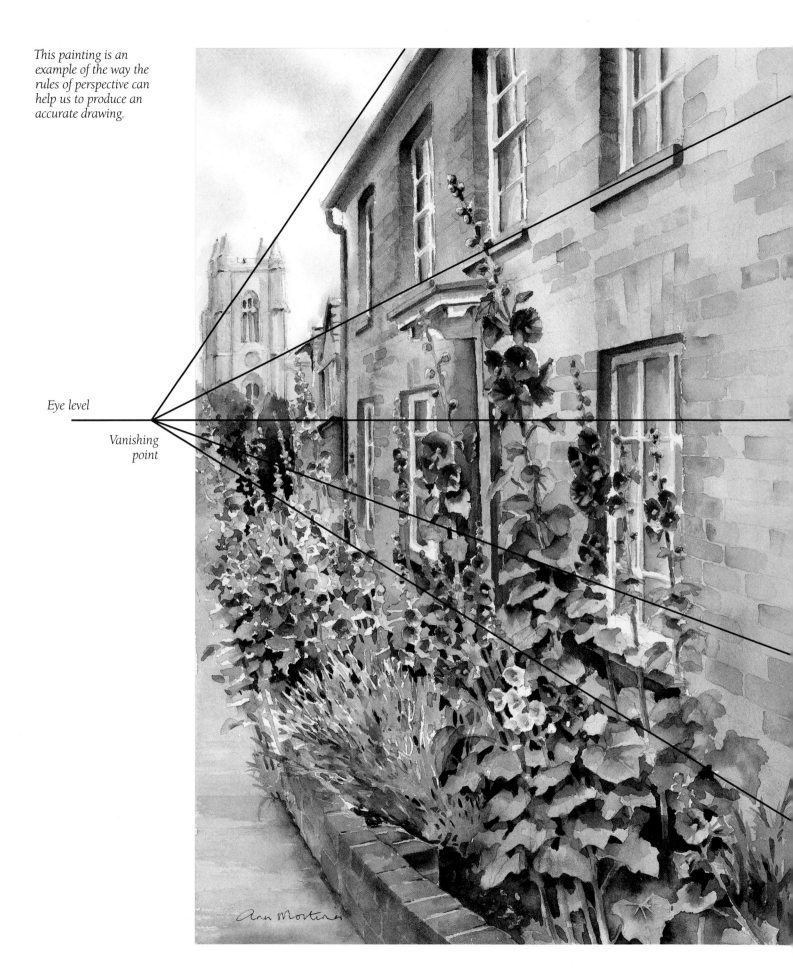

This painting is an example of the way the rules of perspective can help us to produce an accurate drawing.

Eye level

Vanishing point

119

Aerial perspective – trees and flowers

Imagine that you are standing at the edge of a bluebell wood in May. The flowers nestled under the tree next to you will be plain to see in all their detail; the separate tiny bells hanging down from the long, arched blue-green stalks. As you lift your eyes to view the whole scene, however, the bluebells in the distance will appear as a solid mass of lilac blue and single flowers and stalks will be indistinguishable.

This is a good example of how aerial perspective comes into play when painting flowers in the landscape. The flowers in the foreground need to be larger and more detailed. Those in the distance will have much less detail. So these need to be summarised by picking out essential features like their colour and growth habit. Treating the flowers in this way will bring a sense of depth to a painting.

It is helpful to observe the growth habits and essential features of the different flowers in order to be able to portray them convincingly in the middle ground or far distance. Try looking at the scene through half-closed eyes and paint the impression you have gained. This will look much more convincing than if you try to do portraits of the flowers.

Flowers in the foreground need to be quite detailed, as in a flower portrait. In the middle distance you need to summarise the essential features. So for instance with the bluebells in this picture, it is their colour, their arching stems and long arching leaves that identify them as bluebells. In the far distance, you need only give an impression of their colour en masse. Less detail helps to evoke a greater sense of depth.

Geraniums have separate little florets within the flower heads. The individual florets catch the light and create various tones of light and dark within the flower heads. Paint them wet-into-wet in order to show these variegations. The leaves grow in horizontal layers and overlap one another.

Daffodils grow in clumps. They are tall and the flowers are all at the same level above long, sometimes arched, strap-like leaves. In the distance the flowers look star-shaped. Daffodils in the distance can seem little more than yellow dots hanging in mid-air; so that is what you need to paint.

Landscape compositions

This beautiful row of cottages in a Cotswold village with the stream in front and the daffodils growing along its bank seemed to be a ready-made subject when I saw it. The old cottages in their preserved perfection were a good enough reason for me to want to paint the scene, but the stream and the daffodils combined with them to make a great composition.

The light that is reflected from the sky in the foreground stream attracts the eye which then follows the path of the stream into the picture. The shadow cast by the end cottage then sends the eye left to come back round via the daffodils to again rest and linger upon the stream in the foreground. Thus there is a simple composition which provides a journey round the painting. There is little that detracts the eye from its journey.

A composition should have a focal point as well as a way for the eye to find its way to it. When choosing a subject, you have to decide whether you have these things in place. If you do not, then choose another subject or try to edit and simplify the scene until you do.

It is essential to simplify compositions. That way the message that a painting conveys is clear and will have more impact. It is difficult to convince ourselves that we do not need to put every single detail into a scene we have chosen to paint.

Keep asking questions. Is this necessary? Do I really need to include this? Will this detract from the main message? In what ways can I summarise and simplify?

Nobody is going to check your reference material or your memory of the scene to see if it contains every detail. So take charge and have the confidence to make it your painting and your message.

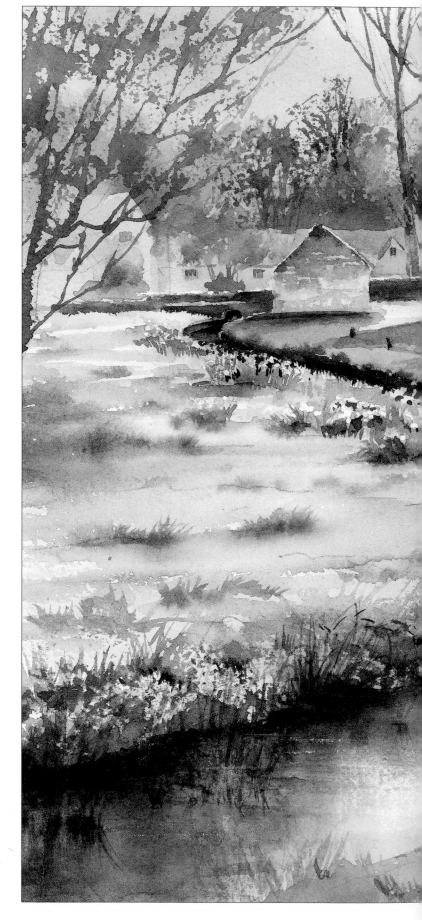

Cottages at Bibury
37 x 27cm (14½ x 10½in)

The stream and line of cottages lead your eye into the scene. The light area and cast shadow at the end of the row have an important role in stopping the eye and taking it back into the picture.

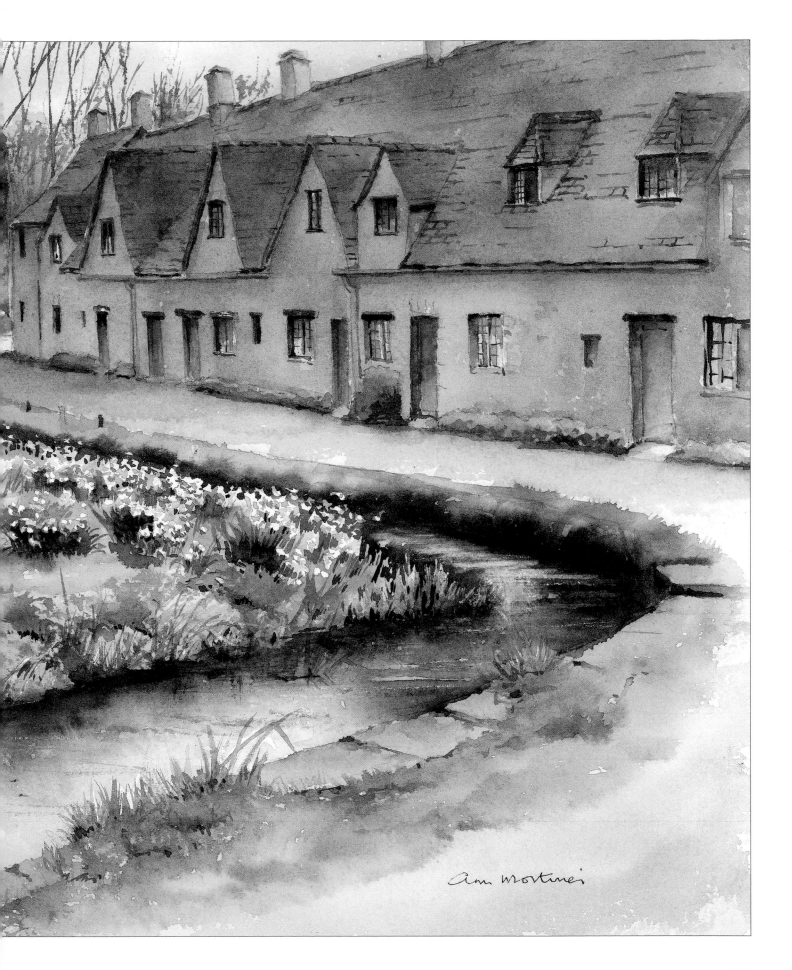

Daffodils and a Stone Wall

When preparing my colours, I place the colours I wish to use in wells. I am careful to make sure than the colours bleed into one another a little in the centres of the wells, but that some of the pure colour remains at the edges. This gives me a great variety of colour, and prevents muddy, over-mixed paint.

You will need

Not surface watercolour paper 425gsm (200lb) 24 x 33cm (9½ x 13in)
Brushes: No. 6 round, two No. 10 rounds and No. 14 round
Watercolour paints: Cerulean blue, Prussian blue, alizarin crimson, gamboge, cadmium orange, viridian, ultramarine, burnt sienna, dioxazine violet
2B pencil
Candle
Masking fluid

Before you begin, mix the main washes:

1) Raw sienna and aureolin (main daffodil)
2) Transparent yellow and aureolin (variant daffodil)
3) Raw sienna, permanent rose and cobalt blue (stone)
4) French ultramarine, Winsor violet and burnt sienna (dark)
5) Hooker's green dark, raw sienna and aureolin (green)

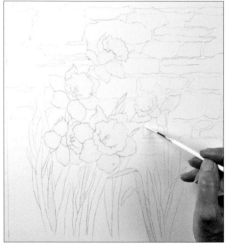

1. With your paper secured to the board, use a 2B pencil to sketch in the main areas of the painting. Use a nylon brush to apply masking fluid to the flower heads and some stalks.

Tip

Cover the wet bristles of your brush with soap to protect it from the masking fluid. Wash it out immediately after use and the brush will not clog up.

2. Continue applying masking fluid and allow to dry. Draw a candle over the top of the stones. It is important to work carefully and not overuse the wax resist technique, as the highlights it creates are permanent.

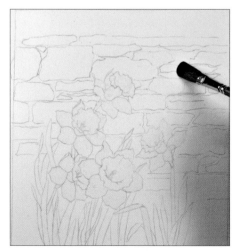

3. Use a large brush to wet the paper with clean water. Allow this to soak in, then re-wet the paper.

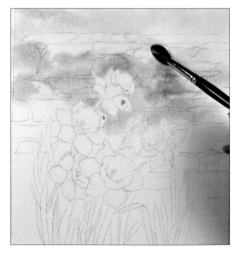

4. Working from the top down, use the No. 12 round brush to apply some cobalt blue to the sky area. Rinse the brush, and then use it to apply varied touches of the stone mix to the wall.

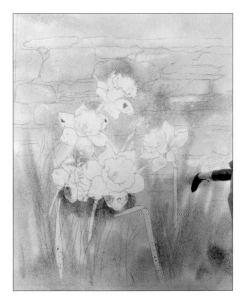

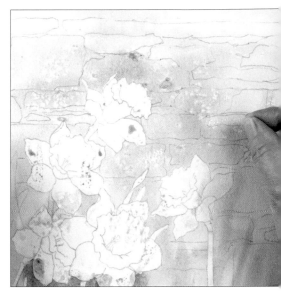

5. Rinse the brush again and apply the green mix around the bottom of the picture, allowing it to bleed into the wet stonework a little at the top. Drop in the yellows over the leaves and stems to show the light. Add a few touches of the dark mix below the daffodils and draw the colours upwards to create stems.

6. While the paint is still wet, pick up the board and gently tilt it back and forth to encourage the colours to merge.

7. Put the board back in place and sprinkle the wall area with salt to add texture. Allow it to dry thoroughly, then brush away the salt.

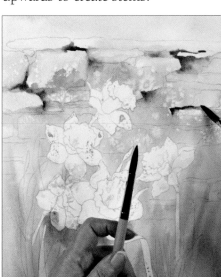

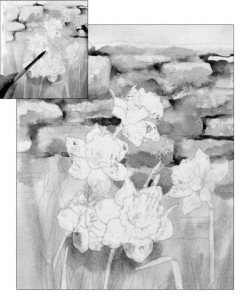

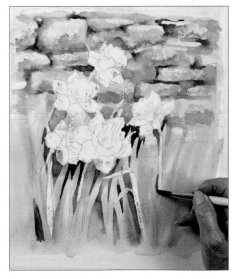

8. Use the No. 10 brush to delineate the bricks in the wall with the dark mix.

Tip

I like to use two brushes at a time: one loaded with the paint, and one in the other hand, loaded with clean water and ready to blend the paint.

9. Continue to delineate the bricks, and introduce texture by drawing the side of a fairly dry brush over the stones (see inset). Aim for a variety of hues in the darks by dropping in touches of the other colours.

10. Use two No. 10 rounds to apply the green and dark mixes to the lower half of the painting. Using French ultramarine and touches of the other colours in the dark well helps to keep the greens interesting. Use negative painting to make some of the stems jump forward as shown.

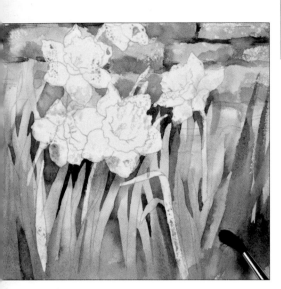

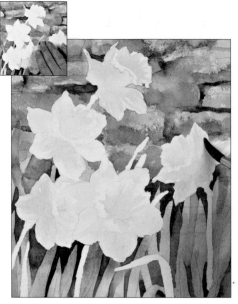

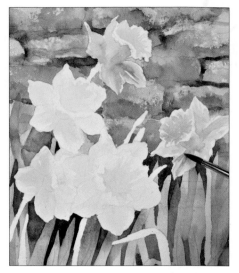

11. Still using the No. 10 rounds, use the green mix with vertical strokes to add some dark leaves and stems on the edges of the painting. Work clean water into the bottom of the brushstrokes to soften them into the background.

12. Allow the paint to dry thoroughly, then use clean fingers to rub away the masking fluid (see inset), then use the No. 10s to lay in a base of aureolin on the daffodils, leaving white spaces of clean paper for highlights.

13. Make a well of Indian yellow and permanent rose, then begin to model the daffodils using this new well with the other two yellow wells. Blend in touches of cobalt blue to add shading.

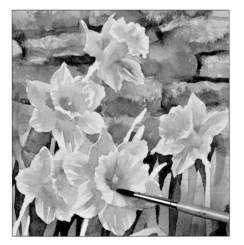

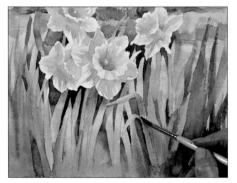

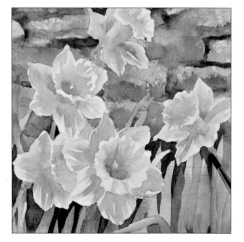

14. Continue to model the remaining flowers with the same colours, using stronger, warmer hues in the centres of the trumpets.

15. Lay in the daffodil mix to the stems and add touches of the green well wet-into-wet, letting the colours bleed into one another.

16. Use raw sienna on the calyxes (the papery cowls behind the flower heads), then shade them by adding burnt sienna in wet-into-wet.

Opposite
The finished painting.

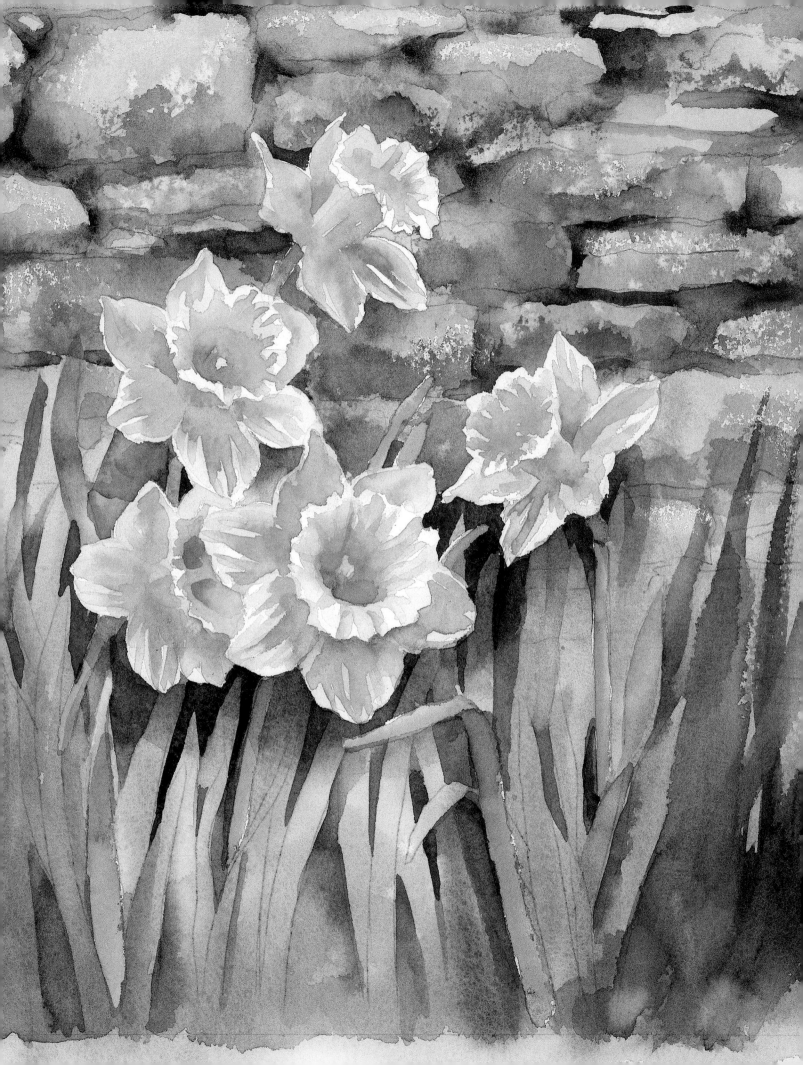

Hellebores

Hellebores are among the first flowers to emerge from the winter gloom in early spring. Their waxy white blooms provide a stunning contrast to the bare, dark-coloured winter soil in a garden or to the sombre bed of fallen leaves in a woodland glade.

Because they flower when the weather is cold and we can not get out much, we often have to resort to various strategies to plan compositions and find source material. Here I have used two photographs: one of hellebores, and one of fallen leaves, gathered in autumn. The leaves were kept in a box in the studio over winter and I used their dried, crinkled shapes for reference to create the feel of a leaf-littered woodland floor.

I love painting these white flowers with their wide open faces and eager stamens which seem to be seeking out the sun. The stamens cast interesting shadows on the white petals. (Purists will know that these are in fact the sepals of the flower and that the petals are the tiny green protuberances right in the centre.)

With this subject there is enormous scope for tonal contrast, which is what I love most of all about watercolour painting.

You will need

Not surface watercolour paper 425gsm (200lb) 38 x 28cm (15 x 11in)
Brushes: Nylon No. 3 round, 16mm (⅝in) filbert, No. 12 round, two No. 10 rounds, No. 6 round
Watercolour paints: raw sienna, aureolin, French ultramarine, burnt sienna, Winsor violet, cobalt blue, permanent rose, Hooker's green dark, alizarin crimson
2B pencil
Masking fluid
Size 0 colour shaper

This photograph was taken next to a sunny window and it provided me with reference for the flower positions and the cast shadow of the stamens in their centres.

This photograph shows the hellebores' leaf formation very well.

Gathered leaves provide valuable reference material.

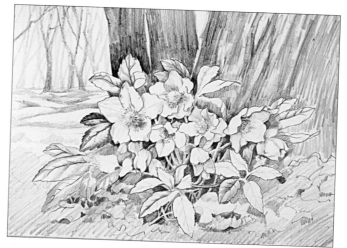

This sketch helped me to work out how I wanted the composition to appear, and to check the balance of light and dark tones within it.

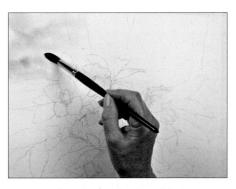

1. Use a 2B pencil to sketch out the main shapes on the paper. Secure it to the board with masking tape, prop the board up and apply masking fluid as shown using the nylon No. 3 brush. Prepare a well of raw sienna and aureolin, allowing them to merge slightly, but keeping them mostly separate. Do the same with French ultramarine, burnt sienna and Winsor violet for a dark well; cobalt blue and permanent rose for a blue well; raw sienna, aureolin and Hooker's green dark for a green well; and some alizarin crimson on its own.

2. Wet the paper thoroughly with the 16mm (⅝in) filbert, then use the No. 12 round to apply raw sienna and cobalt blue to the sky area, adding touches of Winsor violet.

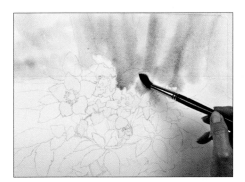

3. Working wet-into-wet, apply raw sienna and burnt sienna to the treeline.

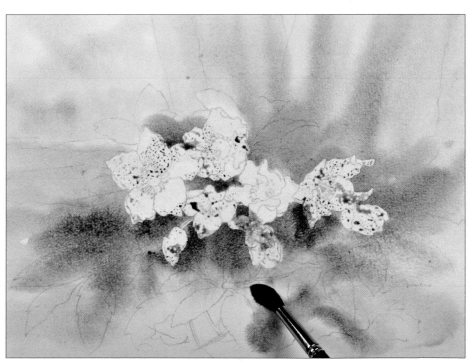

4. Use the green well to add colour around the leaves, then use raw sienna, Winsor violet and burnt sienna for the ground area.

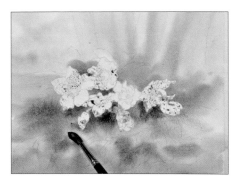

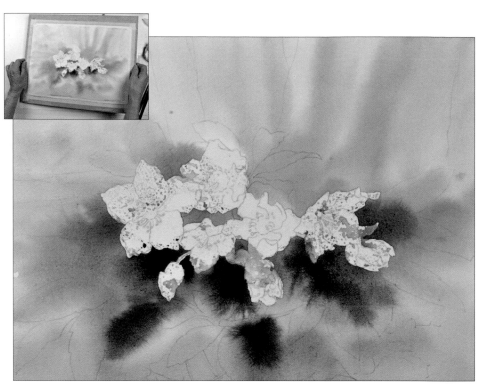

5. Continue adding raw sienna and the colours of the dark well between the leaves of the main flowers. This will heighten the contrast between the leaves and flowers in the finished picture.

6. Pick up the board and tilt the painting to encourage the colours to merge (see inset). Put it back down and add some strong alizarin crimson, French ultramarine and burnt sienna, mixing them on the paper. Allow the painting to dry completely.

Tip

Because I allow my colours to bleed into one another in the wells, the colours listed are approximate – tinges and combinations of the other colours in the wells will affect the exact hues. Do not worry! As long as the colours are not muddy and mixed in your wells, you will get fresh, natural colours from the purer areas, as well as beautiful combinations where they merge.

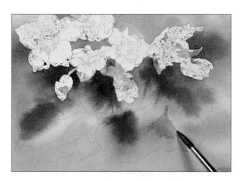

7. Using the No. 10 brushes, lay in some raw sienna next to one of the leaf outlines, drawing it round the leaf.

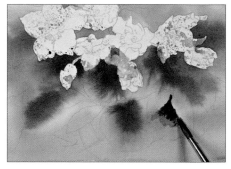

8. While the raw sienna is wet, use the other No. 10 brush to add a mix of colours from the dark well.

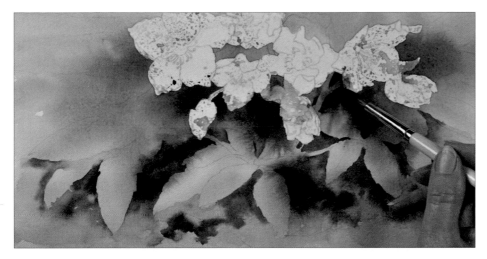

Tip

There is no replacement for good source material, so go into the woods and study the appearance of the woodland floor to get an idea of the texture you are capturing.

9. Repeat this over the rest of the woodland floor, varying the hues and strength of the colours you are using from the dark well. By painting the negative shapes around them in this way, the hellebore leaves are made to emerge from the background of the woodland floor.

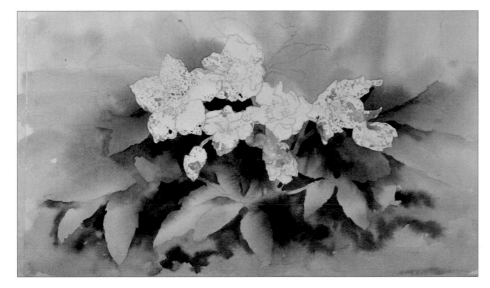

10. Using clean water instead of the raw sienna, and the green well and burnt sienna instead of the dark well, repeat the process across the foliage in the mid-area of the painting.

11. Paint the leaves above the flowers with aureolin, then drop in colours from the green well wet-into-wet.

12. Do the same on the leaves in front of the tree, drawing the wet paint across to form the veins.

131

13. Use the same colours and techniques across the remaining leaves.

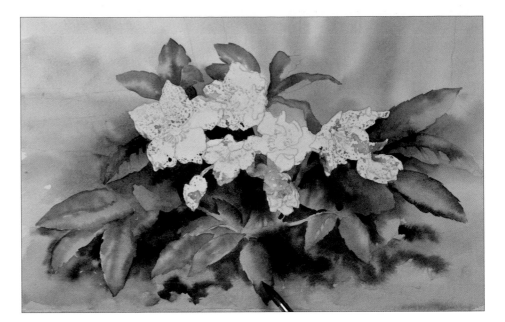

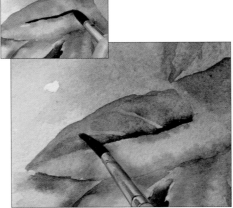

14. Still using the No. 10 round brushes, wet the trees with clean water before using the dark well and raw sienna to make vertical strokes and diamond shapes on the trunks for a bark effect. Emphasise lighter colours on the left and darker ones on the right.

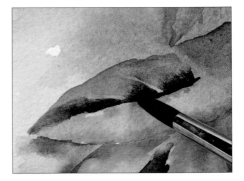

15. Use the tip of a No. 10 brush to draw a line of Hooker's green dark along the midrib of one of the leaves on the lower left (see inset). Add touches of French ultramarine and burnt sienna wet-into-wet, then use a damp No. 6 brush to draw the paint up the leaf, leaving gaps to suggest side veins.

16. Add more dark green with the No. 10 to strengthen the shading, then use a wet No. 6 to draw side veins down over the light side.

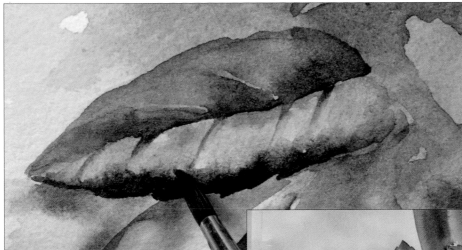

17. Apply dark green along the bottom of the leaf with the No. 10 brush, then draw the colour up with a wet No. 6 brush to emphasise the side veins on the lighter half. Allow to dry.

18. Paint some of the other leaves in the same way.

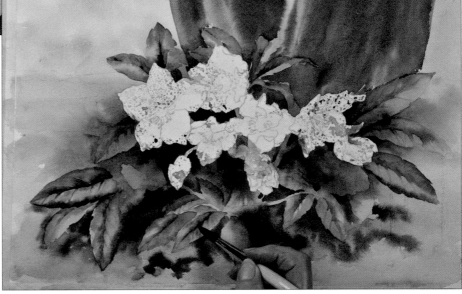

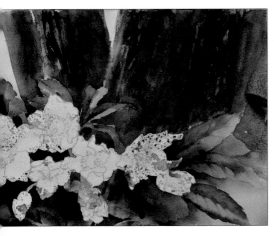

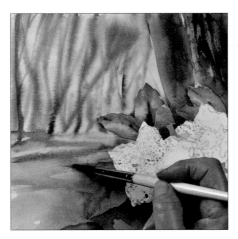

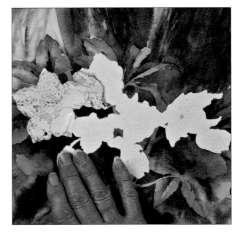

19. Draw the side of the No. 10 dry brush down over the trees in broken strokes to bring out the texture of the paper and suggest bark. Use the colours from the dark well, with an emphasis on burnt sienna.

20. Wet the sky area with clean water, then use the No. 10 round brushes to suggest misty tree shapes and shadows in the background.

21. Allow the painting to dry, then carefully rub away all of the masking fluid with your finger.

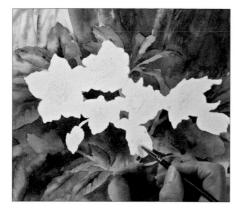

22. Use the size 0 colour shaper to apply masking fluid to the stamens of the hellebores, and allow to dry.

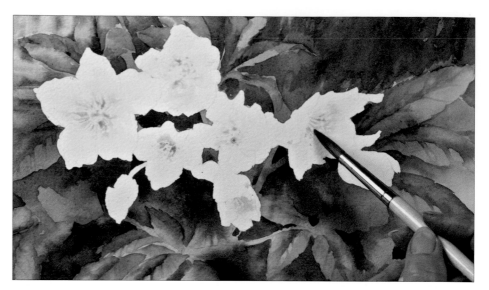

23. Use a No. 10 round brush to wet the flowers with clean water and apply a dilute wash of aureolin to the centres. Vary the hue with touches of the green well.

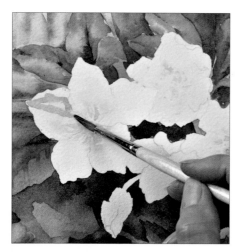

24. Make a dilute mix of cobalt blue with a touch of permanent rose. Use the No. 6 brush to suggest shading on the edge of the leftmost hellebore's petals.

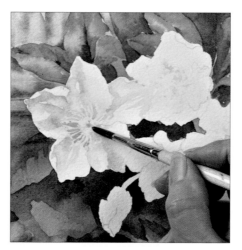

25. Draw the colour in with a wet brush to blend and soften the transition, then paint the other petals in the same way.

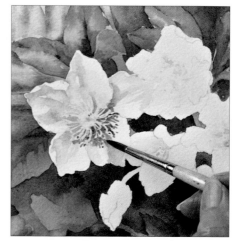

26. Use a stronger mix of the same colour to strengthen the shadows in the centre of the hellebore and to paint in the shadows cast by the stamens.

27. Paint the other flowers in the same way, adding a touch of permanent rose to the base of the opening buds at the bottom. Paint the small leaves using the colours in the green well.

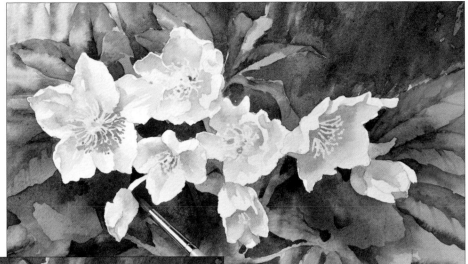

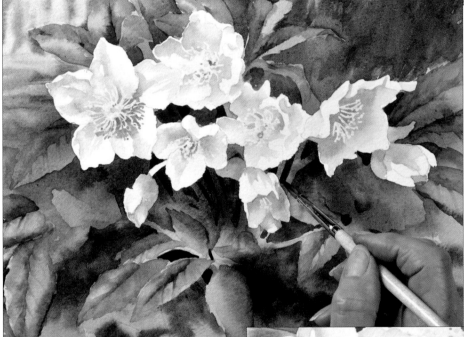

28. With the flowers in place, use the colours from the dark well and the No. 6 round brush to bring out the stems and foliage below them with negative painting.

29. Paint the stems with raw sienna and drop alizarin crimson in wet-into-wet.

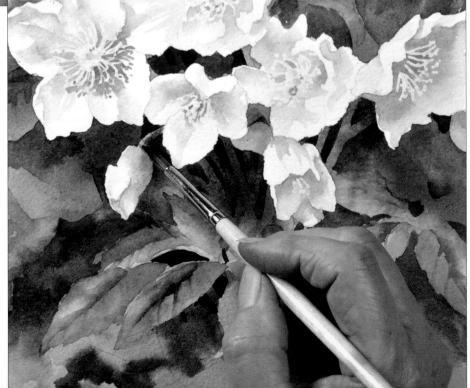

30. Use your fingers to rub away the masking fluid from the stamens (see inset), then paint them with a thin wash of aureolin, using the No. 6 round. Allow to dry.

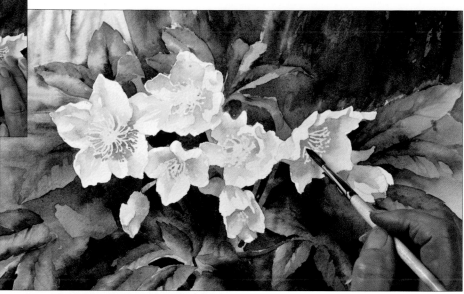

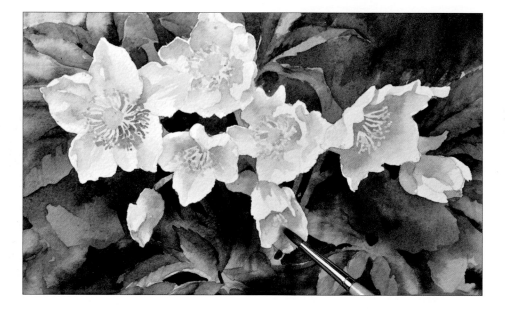

31. Add a little permanent rose to warm the aureolin. Wet the flower centres and drop in the warm colour. Dot the same colour into the ends of the stamens.

32. Warm the colour with a little more permanent rose and use it to shade the yellow areas.

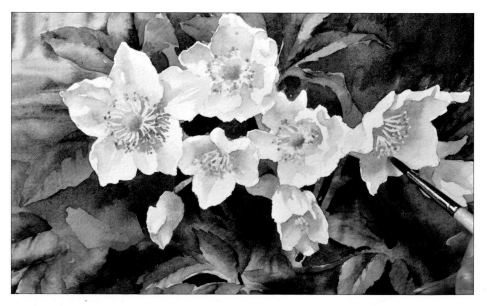

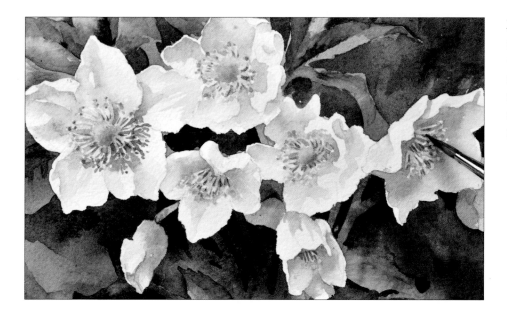

33. Add a dilute touch of the shadow mix to the lower right of each flower centre, away from the source of light. Use a stronger shadow mix in between the stamens with the tip of the No. 6 round brush.

34. Make any final touches to the piece that you feel necessary, then remove the masking tape to finish.

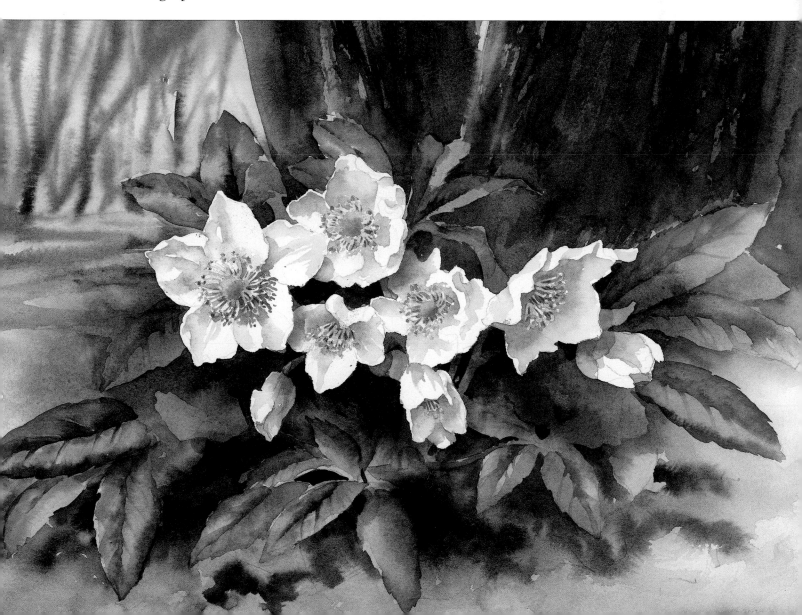

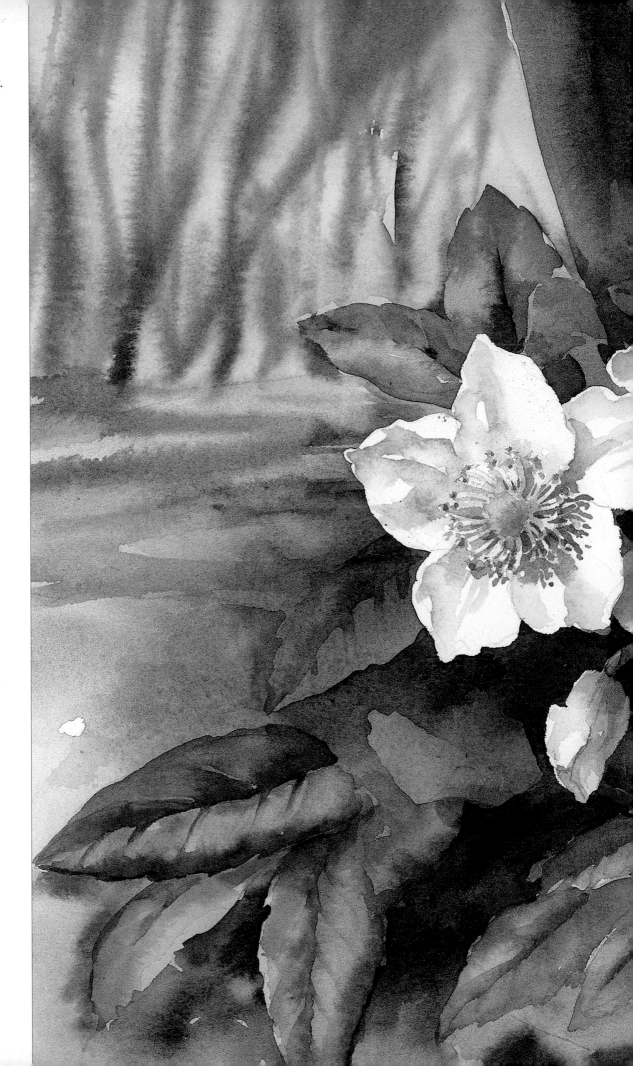

The finished painting.

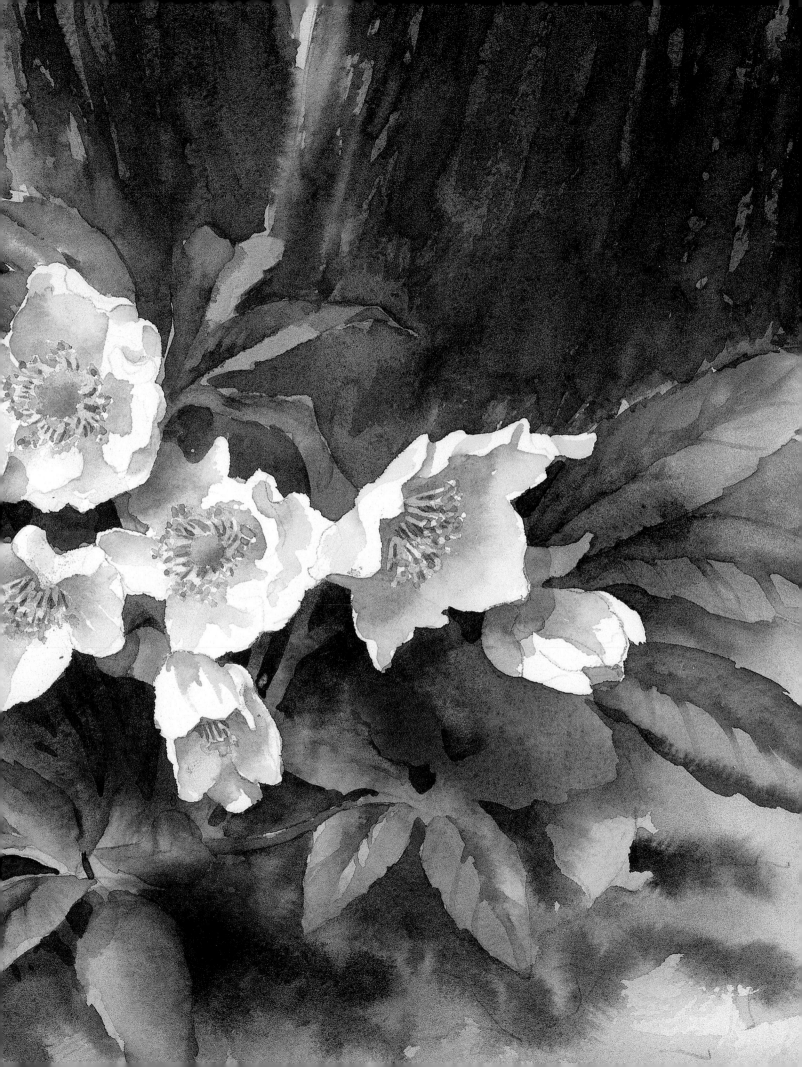

Mailbox and Hollyhock

I like subjects that give a hint of a human presence. This letterbox, attached to a fence outside a village house with the newly delivered mail visible, is just such a subject. I took photographs of the letterbox and a hollyhock flower nearby on the same day and thought of combining the two photograph s into a composition.

Sunshine is an important element in this painting. Cast shadows are one of my passions and the hollyhock is brought to life by the shadow in its centre. It gives it form and depth which is always a good start!

It is important when painting the ivy foliage in this subject, to retain the light and keep it looking sunlit. I did this by weaving darker tones around the ivy leaves so that the yellow areas of the first wash stay untouched and therefore bright and clean.

You will need

Not surface watercolour paper 425gsm (200lb) 28 x 38cm (11 x 15in)
Brushes: nylon No. 3 round, 16mm (⅝in) filbert, two No. 10 rounds, two No. 6 rounds
Watercolour paints: aureolin, raw sienna, French ultramarine, perylene maroon, phthalo turquoise, cobalt blue, permanent rose, Hooker's green dark
2B pencil
Masking fluid

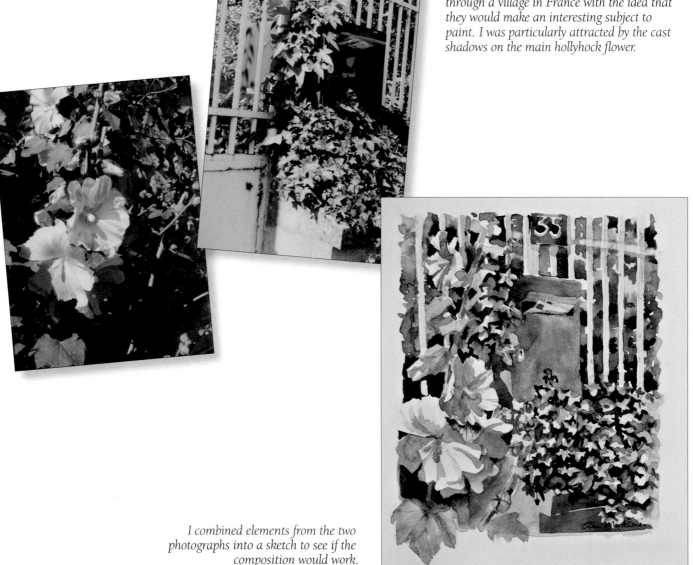

I took these photographs while walking through a village in France with the idea that they would make an interesting subject to paint. I was particularly attracted by the cast shadows on the main hollyhock flower.

I combined elements from the two photographs into a sketch to see if the composition would work.

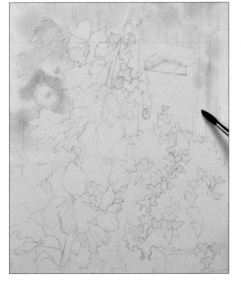

1. Sketch the main shape on to the paper using a 2B pencil and apply masking fluid as shown using a nylon No. 3 round. Secure the paper to a board with masking tape and prop the board up. Prepare the following wells: a yellow well of aureolin and raw sienna; a dark well of French ultramarine, perylene maroon and phthalo turquoise; a shadow well of cobalt blue and a touch of permanent rose; and a green well of Hooker's green dark, aureolin and French ultramarine.

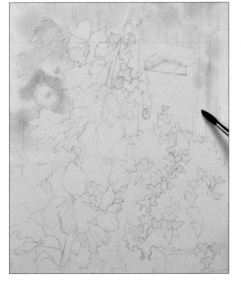

2. Wet the paper thoroughly with a 16mm (⅝in) filbert brush. Working from the top, drop in cobalt blue and colours from the yellow well using a No. 10 round.

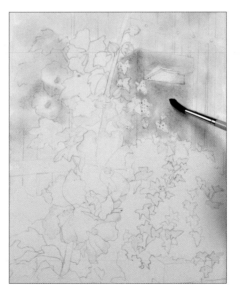

3. Working wet-into-wet, bring in phthalo turquoise over the letterbox.

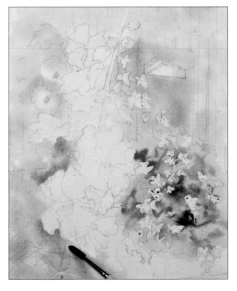

4. Use the yellow and green wells to add colour over the hollyhock and ivy leaves. Drop dark greens into the ivy area, making sure to leave plenty of light areas.

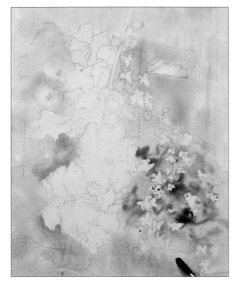

5. Return to cobalt blue for the stonework, and add colours from the shadow well to mute it. Drop in a touch of raw sienna, then allow the painting to dry.

Tip

Be careful to only wet the areas between the railings before dropping in the paint.

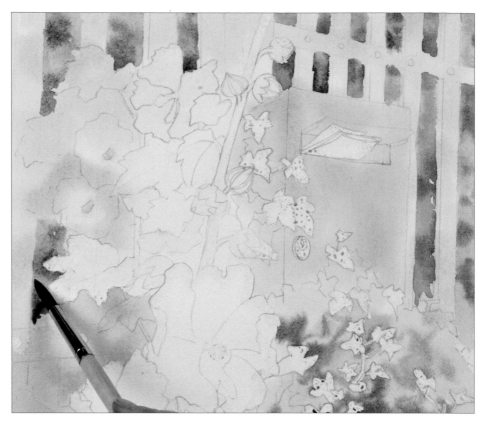

6. Wetting the areas first, use the No. 6 brushes with the green well to create a variegated effect behind the railings, dropping in touches of permanent rose to suggest background roses.

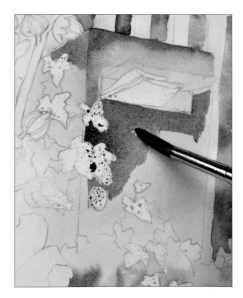

7. Using the No. 10 round brushes with phthalo turquoise and a little perylene maroon, begin to add shading to the letterbox.

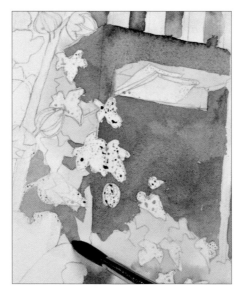

8. Continue with the same colour, bringing out the ivy leaves with negative painting, and leaving some areas of dappled sunlight on the side of the letterbox.

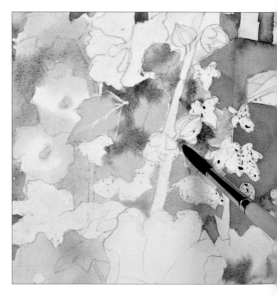

9. Use a dilute green mix to wash over the hollyhock and ivy leaves at the top, introducing darker greens wet-into-wet.

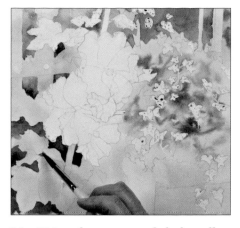

10. Using the green and dark wells, develop the hollyhock leaves at the bottom with negative painting.

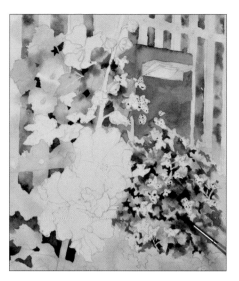

11. Using the No. 6 brushes and the same colours, develop the hollyhock and ivy leaves at the top. Do the same to the mass of ivy on the right, bringing out the ivy leaf shapes with negative painting.

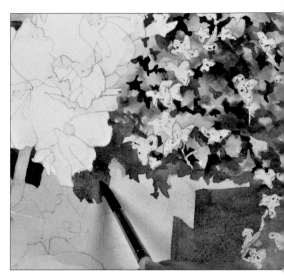

12. Use the No. 10 to paint the shaded part of the wall using the shadow well (cobalt blue and permanent rose) with a touch of raw sienna. Extend the shadow beneath the hollyhock.

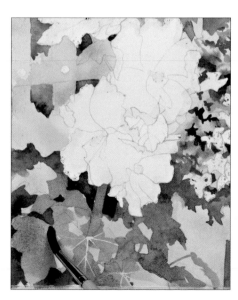

13. Continue developing areas of shadow across to the left.

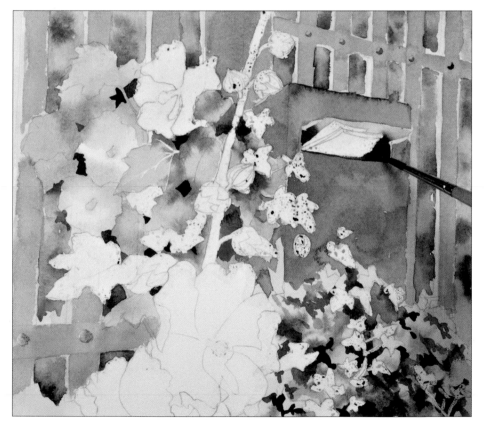

14. Remove the masking fluid from the studs and paint them with a more dilute shadow mix. Use the same mix for the front of the railings, and a stronger mix for the slot of the letterbox. Blend this strong mix upwards using a wet No. 6.

143

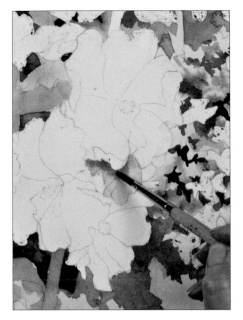

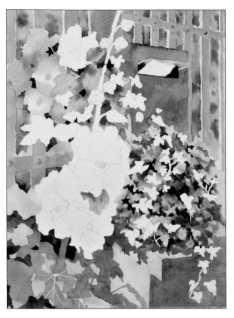

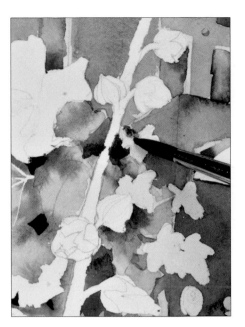

15. Fill in the leaf between the main flowers as for the hollyhock leaves (see step 10).

16. Allow the painting to dry, then use a clean finger to remove all of the masking fluid, except for the centres of the stamens.

17. Starting from the top, drop in aureolin to the ivy areas, then add darker colours wet-into-wet from the green well (Hooker's green dark, aureolin and French ultramarine) to vary the hues in the leaves.

18. Continue painting the rest of the ivy, adding perylene maroon wet-into-wet for the ivy stems.

19. Paint the buds, leaves and stems on the hollyhocks with the same greens, but do not add perylene maroon.

 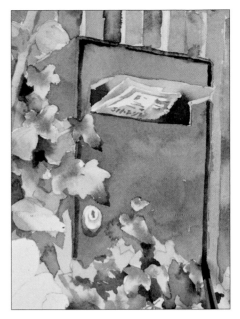

20. Using dilute mixes of the colours from the shadow well (cobalt blue and permanent rose), add some tone to the newspaper in the slot and the lock of the letterbox. Blend the colour outwards using a wet brush.

21. Using a stronger mix of the same colours, use the tip of the brush to suggest text on the envelopes.

22. Use a strong mix of phthalo turquoise and perylene maroon to detail the recesses on the front of the letterbox.

23. Wet the whole of the central hollyhock with clean water, and drop in aureolin to the centre of the top flower, pulling the paint outwards with short strokes.

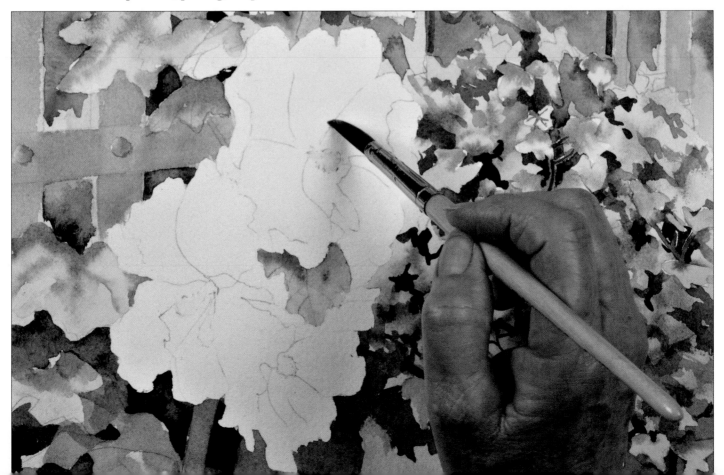

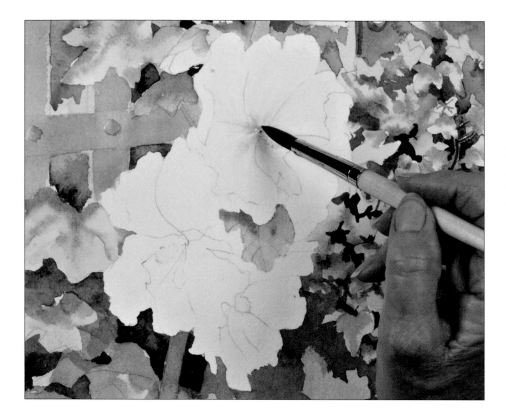

24. Make a dilute mix of Hooker's green dark with a touch of French ultramarine, and drop it in wet-into-wet, drawing it out from the flower centre along the petals.

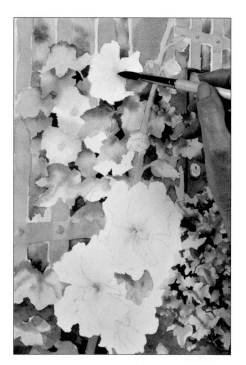

25. Paint the other main hollyhock flowers in the same way.

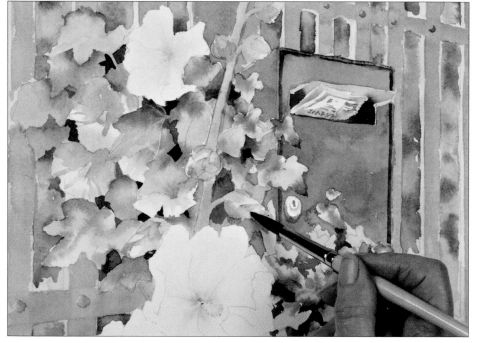

26. Use the shadow well to add modelling to the background hollyhocks and buds. Add a touch of permanent rose to the ends of the buds.

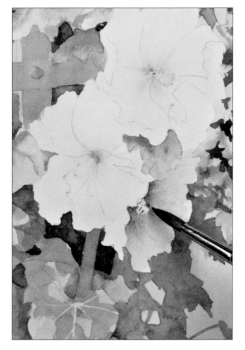

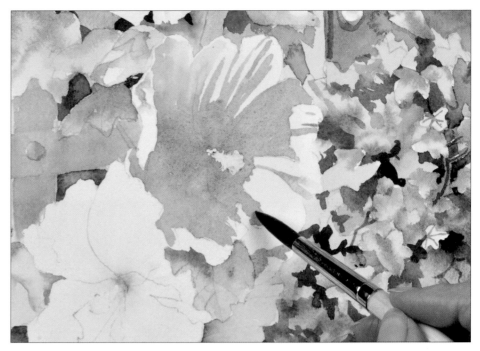

27. Use the same shadow mix on the lowest hollyhock. While the colour is still wet, add touches of permanent rose to warm it a little.

28. Paint the central hollyhock with the same colours, drawing the colour out from the centre to form the shading.

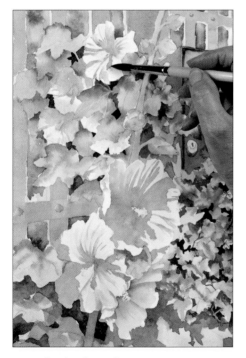

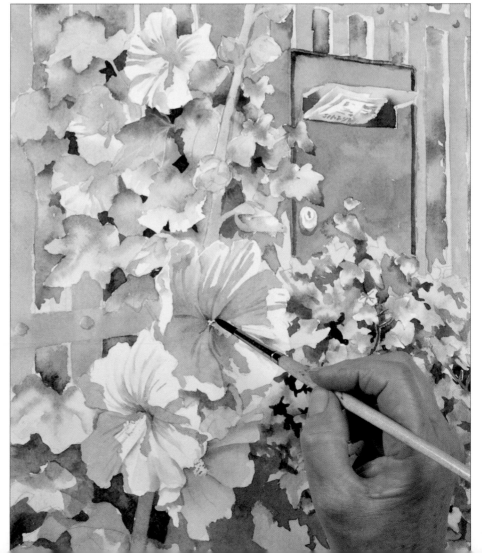

29. Shade the other main hollyhocks in the same way.

30. Once dry, return to each flower and reinforce the shadows with overlaid glazes.

31. Remove the masking fluid from the stamens and use aureolin to paint them. Add some raw sienna to the shadow well colours and drop this in wet-into-wet for shading.

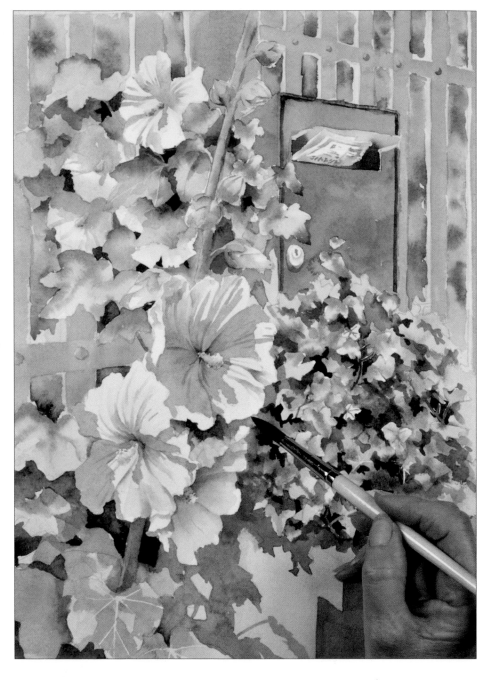

32. Strengthen the darker areas across the painting, using darker colours from the green well (Hooker's green dark, aureolin and French ultramarine) for the foliage and the shadow well for the rest of the picture. Allow to dry to finish.

Opposite
The finished painting.

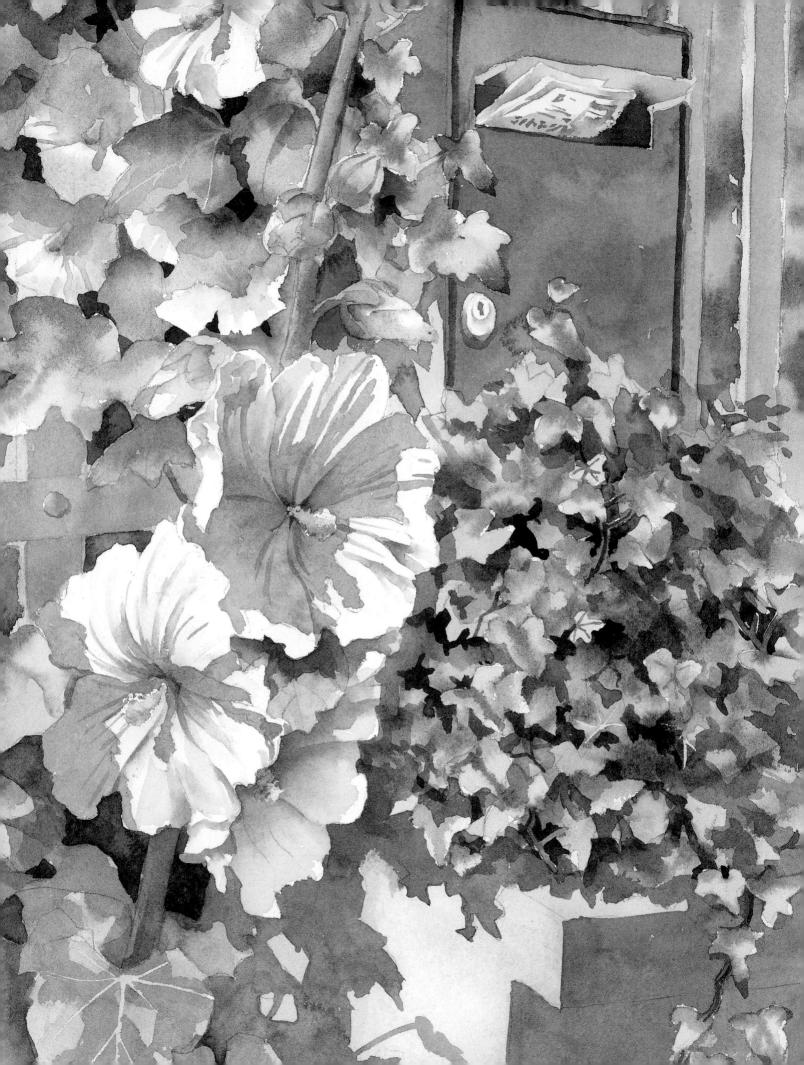

Daisies on a Table

I have painted this vase many times with different flowers in it. It is made from recycled green glass and I like the way the darkest areas of the green glass contrast with the light in the centre.

I noticed how the intense sunshine on this summer's day produced contrasting shadows in the garden, and so deliberately set up this composition, with white daisies and the outrageously dark shadow cast by the vase and flowers.

There is surprisingly little painting involved in this subject. The white flowers are mostly unpainted white paper and the table has only one layer of paint on it. It is a good example of how less is more in watercolour painting. By this I mean that we should aim to put the colour down once and then leave it alone. It is a mantra that my students are probably tired of hearing!

You will need

Not surface watercolour paper 425gsm (200lb) 28 x 38cm (11 x 15in)
Brushes: nylon No. 3 round, 16mm (⅝in) filbert, No. 12 round, two No. 10 rounds, No. 6 round
Watercolour paints: aureolin, quinacridone gold, phthalo turquoise, perylene maroon, permanent rose, cobalt blue, Winsor violet
2B pencil and putty eraser
Masking fluid

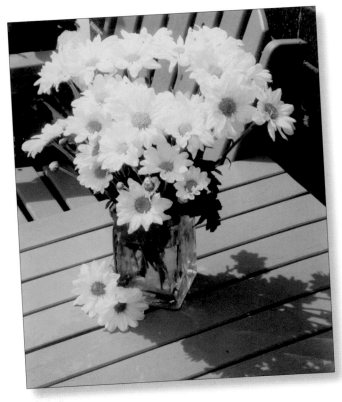

I deliberately placed these flowers in a glass vase on a garden table on a sunny day to create the stunning cast shadows. I took several photographs and chose the one I thought would work best as a painting.

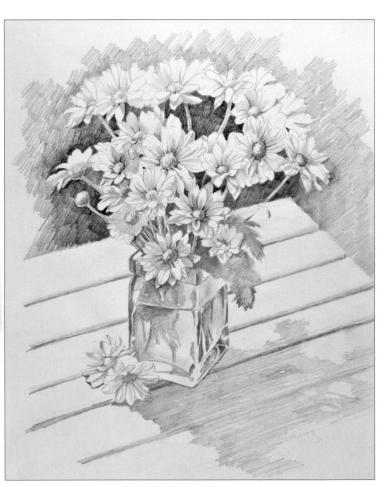

Making a sketch of the photograph allowed me to understand how the flowers overlapped each other and to see how many of them were actually in shadow.

150

1. Sketch the basic shape on to your watercolour paper using a 2B pencil. Secure it to the board using masking tape, then use a nylon No. 3 round to apply masking fluid as shown.

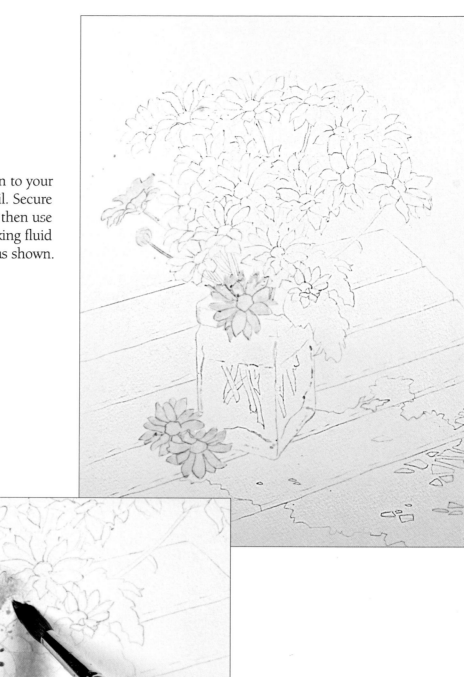

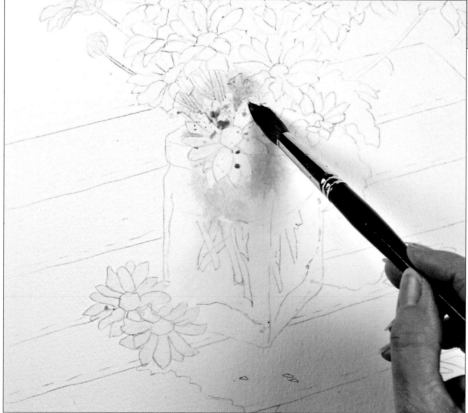

2. Prepare a yellow well of aureolin and quinacridone gold for the light in the vase, and separate wells of phthalo turquoise and perylene maroon. Wet the whole paper thoroughly using a 16mm (⅝in) filbert, then use a No. 12 round to lay in the yellow mix for the sunlight in the vase. Drop in a little phthalo turquoise above it over the masked-out flowers, working wet-into-wet.

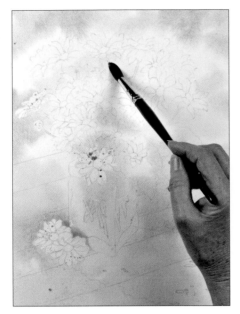

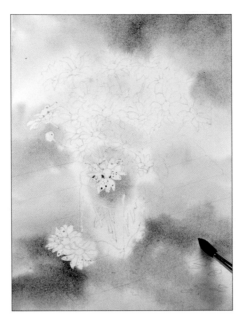

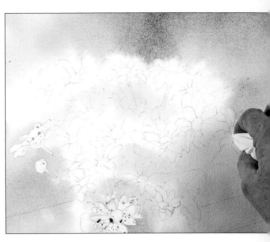

5. Dab kitchen paper on to the flowers to lift out excess paint, then allow to dry.

3. Continue laying in dilute phthalo turquoise over the background, avoiding the daisies.

4. Add in some perylene maroon to vary the background, then mix perylene maroon and phthalo turquoise together for some darker touches.

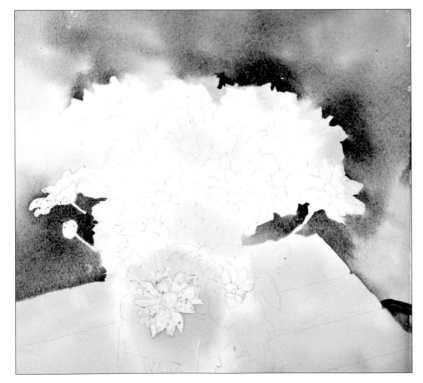

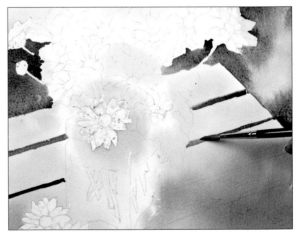

7. Use the tip of the No. 10 brush to paint darks between the slats of the table, then use a wet No. 6 round to blend and soften the line a little.

6. Make a dark mix of phthalo turquoise, quinacridone gold and perylene maroon. Wet the paper around the flowers with the No. 12 round, working right to the edge of the paper, then drop in the dark mix with a No. 10 round to delineate the flower petals.

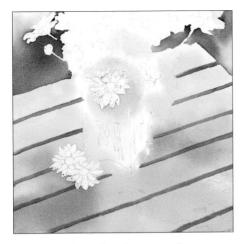

8. Paint the other lines in the same way and leave to dry.

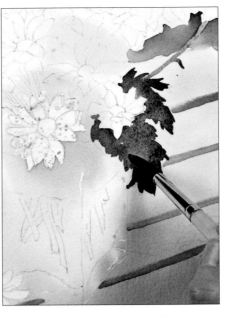

9. Use a wet No. 10 round to wet the leaves, and a second No. 10 to drop in phthalo turquoise and quinacridone gold, allowing them to mix on the paper to make a green.

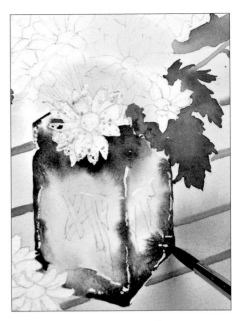

10. Wet the vase, then drop in darks at the edges. Add touches of the sunlight mix in the centre.

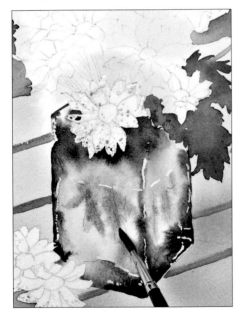

11. Use quinacridone gold and phthalo turquoise to make a green. Use a No. 6 round to apply it to the sunlight mix wet-into-wet to suggest stalks in the water.

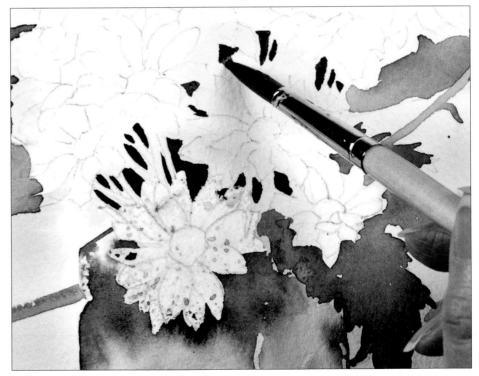

12. Use fairly strong mixes from the dark well to begin to fill in the spaces between flowers, suggesting stems and stalks with negative painting.

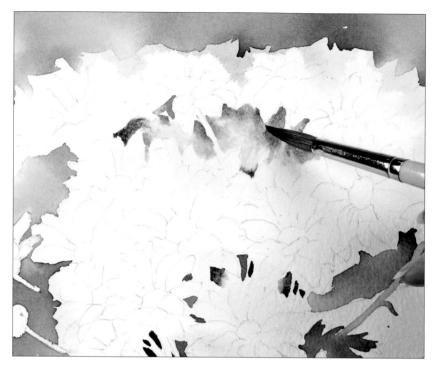

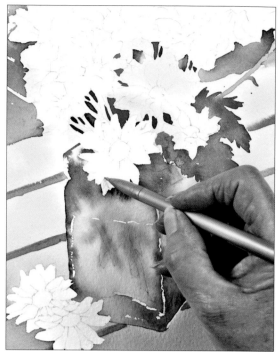

13. For the larger gaps at the top of the flowers, apply a little water, then add the paint wet-into-wet.

14. Allow the painting to dry, then use a clean finger to rub away all of the masking fluid. Use a 2B pencil to reinstate the details on the flowers.

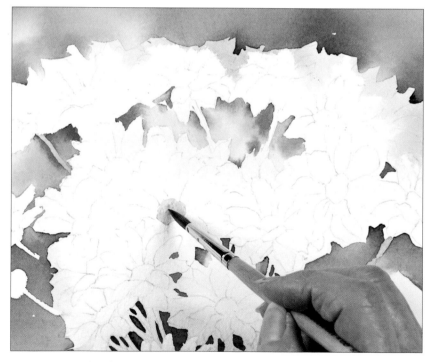

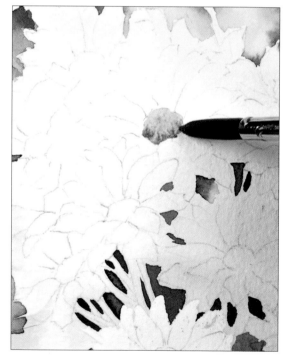

15. Prepare the following wells: a green well of phthalo turquoise and quinacridone gold; a sunlight well of quinacridone gold and aureolin; and an orange well of quinacridone gold and permanent rose. Use a No. 10 round to apply the sunlight mix to the centre of one of the daisies.

16. While the centre is still wet, add in a touch of the green mix with a No. 6 round. Add the orange mix towards the bottom, then allow to dry.

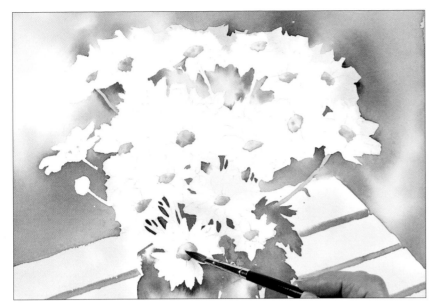

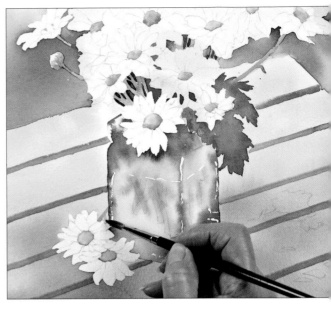

17. Paint the centres of the other daisies in the same way.

18. Use the green mix to model the stems and the bud on the left with a No. 6 round.

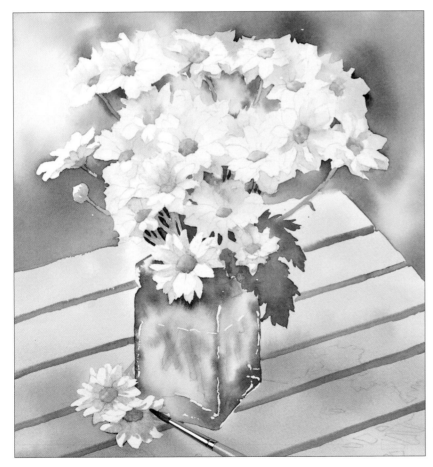

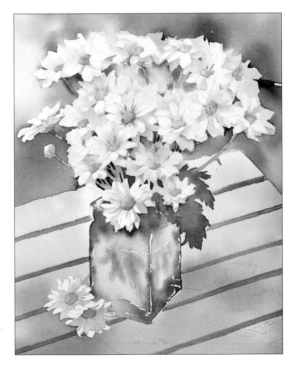

19. Make a shadow well of cobalt blue and touches of permanent rose and aureolin. Use this to paint in the darkest shadows on the daisies. Apply the paint with a No. 6 round, then blend it down with a wet No. 10 round. Drop in some dilute touches of pure permanent rose and aureolin to vary the hue and add interest.

20. Delineate the petals using a No. 6 round, adding a touch of Winsor violet to darken the mix.

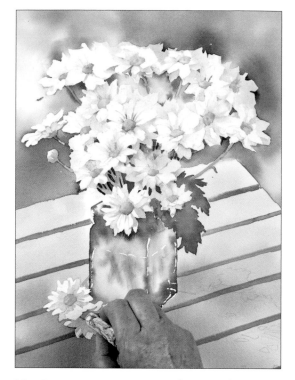

21. Use a putty eraser to rub away the pencil lines.

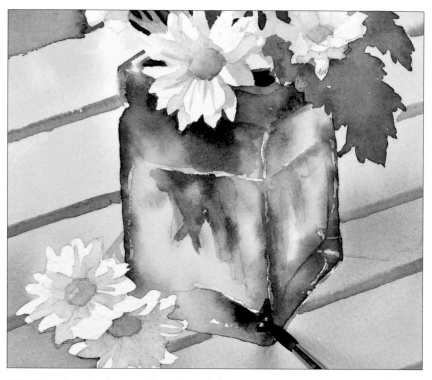

22. Use the shadow well to detail the vase. Use a wet No. 6 to blend and soften the colour, and use the green well to detail the stems.

Tip
It is important to use plenty of water to blend out the pigments and achieve a glassy look.

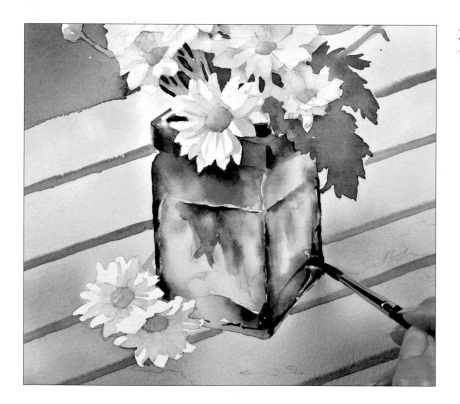

23. Once dry, add a few dark strokes on the vase to increase the glassy impression.

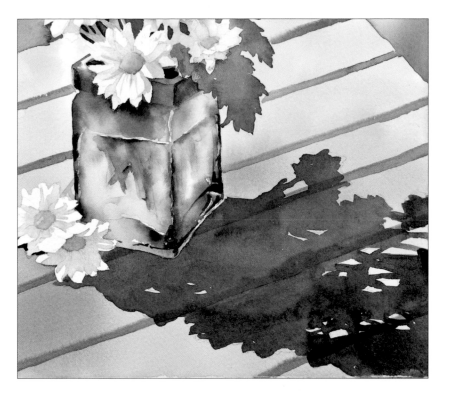

24. Make an extremely dark mix of perylene maroon and phthalo turquoise to paint the shadow cast by the vase and flowers. Make plenty of the mix and keep it fairly dilute.

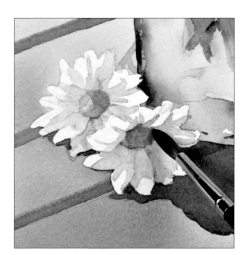

25. Use the cobalt blue and permanent rose from the shadow well with a No. 6 round to detail the daisies on the lower left.

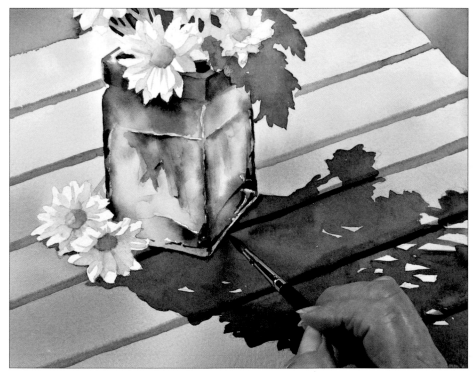

26. Still using the No. 6 brush, make a stronger mix of perylene maroon and phthalo turquoise and use it to deepen the shadows between the slats where the shadow of the vase falls across them. Use the same mix to paint a fine line between the vase and table. This will anchor the vase.

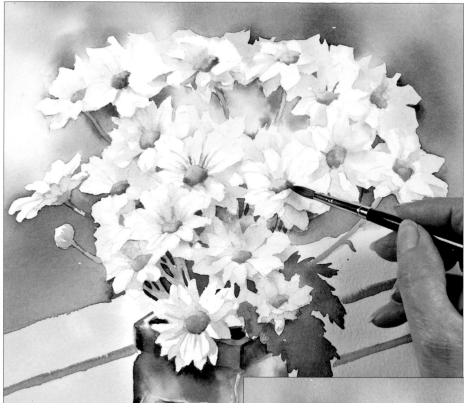

27. Strengthen the centres of the daisies with the sunlight well (quinacridone gold and aureolin) and the orange well (quinacridone gold and permanent rose).

28. Make any final adjustments that you feel necessary to finish.

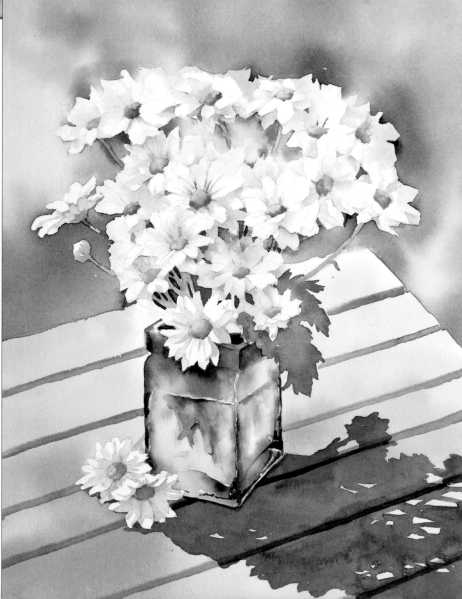

The finished painting
230 x 245mm (9 x 9½in)

Index